PRAISE FOR
RISKY WOMEN

*I got so much more than I bargained for when I began working with Megan—
in the best way possible! Though I went into the experience hoping for a quick
fix to some specific challenges I was facing in my career, Megan helped me
take a step back to think bigger and unlock more influence and potential
than I'd imagined. She didn't give me the easy answers; she made sure I was
asking the right questions. Megan has a special flavor of 'tough love' that
is at once compassionate and challenging. Through our coaching sessions,
she helped me define and refine my own theory of leadership to elevate my
presence and performance, driving effectiveness through authenticity.*

VALERIE KAPLAN • Former CMO, Headspace

*Every ambitious, fearless woman's guide to success. Megan's book provides
practical yet simple and actionable steps to overcome fear and self-doubt on
the road to your indelible right to success.*

AMBER HAMEED • Managing Director, Accenture Song

*Risky Women is a must read for female leaders at all levels! It reinforces the
problems women face but, more importantly, empowers one to take action
that will drive long-term positive change for female leaders.*

CHRISTINA CARTWRIGHT • Former Marketing Executive,
Dollar Shave Club

Women should understand that boundaries and limitations are not the norm. Megan has done an incredible job of laying out a runway to success! Risky Women is a must read!

REBECCA BAST • Founder, Bast Financial Group

Megan's Risky Women is a clever take on how to conquer the workplace by getting curious about the fears and self-doubts that holds us back. Her thoughtful exercises help us create space from those fears and consequently fill that space with a much more lucrative fear in the workplace—the fear of missing out, ultimately unleashing our risky behavior as female leaders.

JILLIAN ROMERO CHAVES • CEO and Founder of Hungry Unicorns, Managing Director of OREMOR Automotive Group

All women need to read to help them move forward in business and in life. The backstories, research and no-nonsense plan help you unblock and grow and show who you really are. This is for all women, whether they are just starting their careers or reaching the top!

SARAH CHESNUTT • Strategic Director, YPO Pacific West

True to form, Megan Ragsdale delivers a hilarious, no-holds-barred reality check on barriers women face to risk taking. She's got the chops and leadership experience to set you up for success to navigate risk anywhere, any time.

JOHANNA HLADUN • Senior Director, Security Services

HOW TO REACH THE TOP LEVELS
OF LEADERSHIP OR KNOW WHEN IT'S
TIME TO GET THE HELL OUT

Risky
women

MEGAN FARRELL RAGSDALE

Cover and interior design by
Andrew Welyczko • AbandonedWest Creative, Inc.

Book production by Broad Book Group, LLC

Hardcover ISBN: 979-8-9867221-0-8
Paperback ISBN: 979-8-9867221-1-5
eBook ISBN: 979-8-9867221-2-2

Library of Congress Control Number: 2022914696

Printed in the United States of America

First Edition

To Grace and Lou, my street fighters in training:
you give me the strength to keep pushing.
Never let anyone tell you that you can't.

LETTER TO THE READER

Dear Reader,

My hope is that the tools in this book will help you create the life you desire without feeling like you need to wait on or rely on anyone else.

I believe that the tools in this book could be applicable to anyone, but I wanted to write directly to women because how we experience the world and the journeys that we travel in the business world are unique.

With that said, this book was written from my perspective, and I want to acknowledge that my journey includes privileges afforded to me that others who identify differently than myself do not receive.

My passion is to help all women succeed as business owners, founders, and leaders, and I hope that one day I will get to hear about your journeys and your successes as we continue to build the new workplace the world needs together.

Megan

CONTENTS

INTRODUCTION
HOW DID WE GET HERE?

"No country can ever truly flourish if it stifles the potential of its women and deprives itself of the contributions of half of its citizens."

MICHELLE OBAMA

NOBODY IS COMING TO SAVE YOU. What's worse, nobody cares! The harsh reality is that the structure of corporate America wasn't designed for women to succeed—but you don't need me to tell you that. You've already lived through it, or you wouldn't be here. I can't change the system or level the playing field. What I can do is provide you with the tools you need and help you sharpen the skills required to navigate that system. That means no longer putting up with the bullshit, settling for less, or waiting for someone to bestow upon you what you know you have already earned. Consider this the street fighter's manual on how to go out and take what you want and deserve.

I think Ruchika Tulshyan and Jodi-Ann Burey had it right when they said to stop telling women we have impostor syndrome.[1] This is the wrong kind of heuristic to keep reinforcing in the workplace. We think that because other people keep questioning our right to be there, it means we don't belong, and that it's because of some fundamental flaw in our performance—or worse, in our nature. We are not impostors; we are leaders-in-waiting, playing the role of dutiful worker bee, but somehow never trusted with actual organizational power.

Those with the gold make the rules, and unless you are the queen of your own castle, you will always be playing by someone else's rules. And in most cases, they will not be fair to you, and you won't be able to follow them while keeping some shred of your soul or integrity. I say this as someone who has vacillated between life as a one-woman band with entrepreneurship and life leading teams in corporate America for more than twenty years. Even after earning my place in the C-suite, I still get tested and screwed with all the time. All! The! Time!

Have you ever thought about how no one seems to agree on the competency of any female U.S. politicians? Without getting into party issues, just try to think of *any woman politician* that people respect. Just one. It's always some version of, "I'm fine with a woman in that role. Just not *that* woman." The more powerful we become, the higher we rise, and especially the more we own it, the more we all become *that woman*. Becoming *that woman* can be scary. Those who are at the front lines storming the castle will always get the most battle scars. But *that woman* is something worth fighting for. *That woman* is just another way of saying, "Rather than admitting that I don't think women are competent enough to lead at this level, I will choose instead to focus on her appearance, voice, clothing, or [insert other irrelevant dumb characteristic here]." If you're trying to succeed at the highest levels, *that woman* is you. She is every woman who has come before and after you who will fight for her space in the world. *That woman* is your daughter, your sister, your coworker, and your friend.

When it comes to this fight, there is one skill in particular that I believe is the most valuable, and it's one that most people overlook because few think of it as an actual skill. I'm talking about risk-taking. The only way any of us can get what we want is by betting on ourselves to succeed. That means we must trust ourselves enough to make the decisions and take the chances that are good for us, but this is more difficult than we realize:

1 Ruchika Tulshyan and Jodi-Ann Burey, "Stop Telling Women They Have Imposter Syndrome," *Harvard Business Review*, February 11, 2021. https://hbr.org/2021/02/stop-telling-women-they-have-imposter-syndrome.

as women, we are already at a disadvantage when it comes to risk-taking, even in its simplest form.

Something else you don't need me to tell you is that the system we are forced to operate in is deeply rooted in bias. Picture an iceberg. The part we can see on top is the obvious bias and negative stereotyping we've all experienced. We know how it can impact women at work, simply by what people can observe (and judge) on the surface. These biases complicate our ability and willingness to take additional risks. They include things like race, physical attractiveness, sexual orientation, gender identification, age, and physical abilities.

But in addition to the surface bias we experience, much more damaging gender conformity expectations and stereotyping lurk below, and they also have a significant impact on our risk-taking ability.

Our culture views women as more risk-averse than men, when we are in reality much more at risk.[2] Women are more likely than men to be victims of rape, intimate partner crime, domestic violence, sexual trafficking, and poverty.[3,4] These are the obstacles we as women face right out of the gate, coupled with the constant drumbeat of the media telling us that we are not beautiful enough, smart enough, thin enough, tough enough, brave enough, or likable enough.

From the moment we're in utero, judgments are being made about the role we're supposed to play in society. As we grow up, we're told to play it safe and be careful with our behavior, decisions, bodies, and careers. By the time we're adults, if someone even utters the word "risky" about a decision we're making, we back off because we've been trained since early childhood that risks are bad and that we'll get hurt. What begins as being

[2] Sheryl Ball, Catherine C. Eckel, and Maria Heracleous, "Risk Aversion and Physical Prowess: Prediction, Choice and Bias," *Journal of Risk and Uncertainty* 41, no. 3 (2010): 167-93. doi:10.1007/s11166-010-9105-x.

[3] "Violence Against Women," World Health Organization, last modified March 9, 2021, https://www.who.int/news-room/fact-sheets/detail/violence-against-women.

[4] Robin Bleiweis, Dana Boesch, and Alexandra Cawthorne Gaines, "The Basic Facts About Women in Poverty," The Center for American Progress, last modified August 7, 2020, https://www.americanprogress.org/article/basic-facts-women-poverty/#:~:text=In%20the%20United%20States%2C%20more,or%2021.4%20million%E2%80%94were%20women

told not to jump off the jungle gym evolves into staying in a job we hate because we need the security. Worse, we can become afraid of failure, making it more difficult to define and fulfill our needs and desires.

As soon as people found out that I was pregnant with girls they told me how lucky I was because girls will "take care of you." Whether we're talking about children, the elderly, or even being a community organizer, women are expected to take on the lion's share of that dependent burden. These messages can't help but seep into our subconscious, and before we know it, we've internalized that expectation, too.

We've been told for years to speak up, lean in, ask for that promotion, and not take any crap, but when we do, we're defying the traditional "feminine" behavior that society expects from us, and we are judged harshly for it. But if you lead with that traditional feminine behavior, you will often be considered meek and unworthy of respect.

The expectations today are that women are going to be more agreeable in their style than men, so when you are someone like me who is direct, forthright, and outspoken, you get labeled as disagreeable or difficult. I've watched this happen time and time again. As a coach and business strategy consultant, I am often called in because companies want to invest in their female leaders, but when I arrive, I realize they are expecting these women to succeed in an environment that doesn't really accept them or their style of leadership.

This is known as the likability versus competency dilemma, or the double bind, which refers to the research that has been conducted over the years and was made somewhat famous in Sheryl Sandberg's 2013 book *Lean In*, about how women are penalized for their success.[5] In other words, the more competent a woman is, the less likable she is judged to be, and she is liked even less if she acts authoritatively. The reverse is true as well: if a woman leader is liked, she is perceived as less competent. Interestingly, if female leaders behave more collaboratively

5 Susan T. Fiske, Jun Xu, Amy C. Cuddy, and Peter Glick, "(Dis)respecting Versus (Dis)liking: Status and Interdependence Predict Ambivalent Stereotypes of Competence and Warmth," *Journal of Social Issues*, 55(3), 473-89. https://doi.org/10.1111/0022-4537.00128.

and communally, they are liked more (this adjusted behavior requirement is not a condition placed on male leaders).

These biases and the additional burdens society places on women make our risk-taking calculus more complicated than it is for many of our male counterparts and leave many of us questioning our capabilities and worth when we deserve to be heard, seen, respected, and made to feel proud.

This is one of the main reasons there are still so few women in leadership positions in corporate America today. It's why we are often overlooked as job candidates, passed over in favor of one of our male colleagues, or not even considered at all. However, these factors get dismissed in my least favorite phrase in corporate America: "I don't care whether the candidate is male or female. *I just want the best person for the job*." Really? If I had a dollar for every time I've heard that from leaders who were struggling with their business cultures, I would have retired long ago. If they really just want the best person for the job, why are women leading only 33 of the 500 most powerful companies in the US?

Without any guardrails to protect against bias, companies will most often default to the male candidate, because he generally has the most traditional background and experience. And he is almost always a person of privilege who has been given more educational and professional opportunities (including mentoring) than women, who are underrepresented in the workplace. The system does not accommodate those who don't fit inside this narrow box, but it's a hell of a lot easier to say "I just want the right person for the job" than it is to ensure that hiring is a fair and equitable practice: making certain that your language is fair and neutral, controlling your interviewing process for bias, and intentionally casting a wider net to capture nontraditional candidates. That starts by taking a closer look at your hiring managers to determine if they are the right people to build a diverse and inclusive work culture.

Promotions pretty much go the same way for women. I have been privy to many leadership performance reviews and 360 evaluations over the years, and I can tell you that men rate themselves much higher on their performance than women do. By a lot. Several studies have confirmed my anecdotal observation.[6] I've also found that when debriefing 360 evaluations, where your peers can provide you with anonymous feedback,

men are much quicker to dismiss their negative feedback, while women zero in on any negative commentary like a homing beacon. And women are getting borderline laughable feedback.

We've all heard that women only apply for jobs when they believe they are 100 percent qualified for them. What I see is women who are 115 percent qualified for the positions they apply for, and organizations running out of excuses for why their stellar performance did not earn a raise or promotion. Rather than build her up and focus on her strengths, they nitpick at what they often call her "development areas," which in many cases is thinly veiled sexist feedback that would never be delivered to a man in the same position. She's told that she's "not quite executive enough," or "not collegial enough." They aren't trying to cultivate "executive presence" as much as they are trying to encourage their female leaders to be less ambitious, more friendly, and less intimidating— basically, to just shut up and fit in.

This takes its toll. I've watched hundreds of women take this feedback and put themselves through the painful process of introspection, self-doubt, peer-driven schadenfreude, and self-censorship just so they can satisfy the people seemingly in control of their fate and prove they have been whipped into shape. Meanwhile, they slowly break down and become a shadow of their former glorious selves because on some level, they've internalized that they are total fuckups. They begin to doubt their decisions and become less willing to take risks.

I know because that was my experience as well. After years of intrapreneurship inside Fortune 100 companies—starting new business lines, repairing failing departments, and teaching people how to innovate—I made the decision to start my own business. Today I'm the leader of a best-in-class retail company, a board member of a prestigious organization, a business owner, and, now, an author. But even at this level, I still see firsthand how much of an uphill battle women face in the workplace. That's what led me to write this book.

6 Christine L. Exley and Judd B. Kessler, "The Gender Gap in Self-Promotion," *The Quarterly Journal of Economics*, 2022, qjac003, https://doi.org/10.1093/qje/qjac003.

As an executive coach, I'm called in to help companies scale. I've worked closely with CEOs to create more inclusive and higher-performing corporate cultures. I've been privy to employee feedback and evaluations and worked with executives who were identified as having behavioral or performance challenges. As someone who operates as an executive-level leader outside of my own coaching and consulting business, I hold myself accountable to practice the leadership behaviors I teach.

After talking to thousands of professional women, I could clearly see patterns developing, and I found myself offering the same advice again and again because women everywhere were dealing with the same issues. Countless women found themselves at a point in their careers where they were unhappy and paralyzed with indecision. They had been stuck on autopilot, kept busy with the daily cadence and rituals of their lives, but without really understanding why they were doing what they were doing—or if they were even enjoying it. But they were experiencing a sense of unfulfillment, or restlessness. Their professional accomplishments had lost their flavor and started to feel as unsavory as a bite into an unsalted rice cake. Does this sound like you right now?

Because this is when I usually meet you. You spend our first meeting circling me like a prizefighter, assessing whether I am friend or foe. During our second meeting, you confess that you down a bottle of wine at night and sometimes cry in the bathroom at lunchtime. You admit to fighting with everyone around you—at home and at work—and you aren't even in your own corner. Not really. You're great at defending yourself, but you don't actually love yourself. You're not sleeping well, eating well, or taking care of yourself physically. When I try to lovingly point this out, you remind me how busy you are. You tell me that everything is fine; the real problem is that Jeff is such a raging asshole. If he wasn't trying to sabotage you, everything would be great. If Sara wasn't trying to get in your goddamn swim lane, you would be fine. You fill our time together with stories about how fucked up everyone else's business area is, your many grievances about what people have done and said to you all week, the incompetence of your leaders, and a blow-by-blow of the recent fight you had with your boss over Slack. If I try to move things along, you think that I'm trying to "fix" you, just like everyone else does, so I patiently wait

you out. You want me to like you and understand that it's not you, it's everything and everyone else, but I already know that. I already like and respect you. I am simply waiting for you to quiet down that version of you who feels like she has something to prove, so that I can get to know the real you: the one who has something she desires, but it's buried too deep or sounds too big to say out loud.

This is when our real work together begins. If you're reading this, I know it's because you are good and pissed off. And rightly so! You've put up with a lot of bullshit, but I want to give you the tools to start reframing your story, so you can take back control of the narrative of your life.

I'm going to coach you using the same framework I developed years earlier to rediscover myself and reconnect with a time in my life when I felt powerful, vibrant, and alive. I've since used this framework to help hundreds of other people take risks that bring them closer to their purpose and potential. It focuses on the core areas that will help you properly identify your emotions and restore your confidence, while building that risk-taking muscle that will allow you to tap into your true potential. Fittingly, the acronym for this framework is **"FIND HER."**

- **F** Fear
- **I** Intuition
- **N** Need
- **D** Drive
- **H** Habit
- **E** Empowerment
- **R** Risk & Reward

These topics have been written about individually in other books, but my method is extraordinarily effective because it combines all of them into a process. That's essential because they are all connected. They involve the same emotions and behaviors, so they build off one another.

This book will give you the same benefit my clients receive in a session with me, which is the ability to observe yourself without judgment, so you can unpack whatever is holding you back from your purpose and potential. I know the feeling of being constantly on trial, thanks to a

biased system, is exhausting, but I want to help you differentiate between systemic issues, which are harder to control, and self-inflicted wounds, when you are being your own worst enemy. Although we're necessarily talking about a system that is not set up for us to succeed at the highest levels of leadership, I don't intend to make you feel like a victim of your circumstances, with no power or agency. I want to give you the tools to help you navigate these waters, without feeling like you must force yourself into a mold or a style that doesn't work for you.

We women stand at a pivotal moment in time. The world cannot afford to lose us from the workplace. Not only does having more women in leadership positions improve performance, profitability, and innovation, but female leaders are also role models for creating psychologically safe work environments where employees can be themselves, learn, and make mistakes without fear of retribution.[7, 8] Looking at business through the lens of women will help us create companies with stronger cultures, businesses that focus on impact as much as profit, and initiatives that involve collaboration, not only across departments, but also around the world.

The one commodity we all have is time. Don't waste yours in a place that doesn't appreciate or value you. You have the power to control your own destiny if you choose to take it back.

I believe that if women collectively woke up one day and decided we were no longer going to put up with shitty relationships and unfulfilling careers, there would be a revolution in the streets. And that's what I want you to do: revolt against anything that is keeping you from your true purpose and potential. Life is too short not to take risks. Let's dive in and learn how you can make this dream a reality.

7 "Women Matter 2: Female Leadership, a Competitive Edge for the Future," McKinsey & Company, accessed July 8, 2022, https://www.mckinsey.com/~/media/mckinsey/business%20functions/people%20and%20organizational%20performance/our%20insights/female%20leaderships%20competitive%20edge/female%20leaderships%20competitive%20edge.pdf.

8 Christy Birmingham-Reyes, "Women Leaders Drive Innovation in Business, Research Says," When Women Inspire, accessed July 8, 2022, https://whenwomeninspire.com/2020/06/17/women-leaders-drive-innovation/

CHAPTER 1: FEAR

THE MONSTER IN
YOUR HEAD

"Fear, to a great extent, is born of a story we tell ourselves, and so I chose to tell myself a different story from the one women are told. I decided I was safe. I was strong. I was brave. Nothing could vanquish me. Insisting on this story was a form of mind control, but for the most part, it worked."

CHERYL STRAYED, *Wild*

I WAS A KID WITH A LOT OF FEARS. I feared the darkness in my open closet, the space underneath my bed, and jumping off the high dive. As I grew older, I spent a lot of time finding new reasons to be afraid, and that didn't go unnoticed by the people close to me. One night when I was eight, my older sister, Janine, hid between my bed and the wall for an entire hour before I came into the room. She remained there for another ten minutes until I drifted off to sleep, and then screamed, "Raaaaahhhhhh!" as she jumped on top of me and pinned my arms to the bed. I managed to wrestle free but could still hear her cackling as I ran screaming down the stairs to find my mother.

We are born with fear like that. My sister grabbing me in my bed lit up my brain and engaged my fight, flight, or freeze response, and my body responded accordingly to get me out of there. Only after I was in the safety of my mother's arms was my mind able to comprehend that the "threat" was just my psychotic older sister.

Unfortunately for us humans, the gift of threat detection, which helped keep us safe thousands of years ago when we had to protect ourselves

from predators much larger than us, still causes our bodies to react the same way, even when the threat is minor. A shitty email from a boss, an argument with a friend, or even speaking up during a meeting can take on the same significance in our mind as a saber-toothed tiger. And we don't always have a say in the matter. Whether we are afraid to do something or are suddenly triggered into action by something we heard or saw, our bodies can take over before our thinking brain has even been engaged.

The limbic system is in charge of our fight/flight/freeze mechanism and creates an *automatic response* to a perceived threat. When we are triggered to feel fear or anger by something in our environment, a part of the limbic system called our amygdala (a.k.a. our lizard brain) provides a response to the perceived threat. So, when you decided to shoot off a rapid-fire, passive-aggressive email reply at 9 p.m. after a glass of cabernet to put that annoying colleague in his place, only to regret it as soon as you hit "send," that's the amygdala at work.

While our amygdala is quick to react, the frontal lobes in our cerebral cortex are our much more rational and advanced thinking system. That's why you haven't drop-kicked the asshole who keeps stealing all your good ideas in meetings. What's interesting is that your amygdala and your frontal lobes can override each other, depending on the situation.

I watch a lot of true crime shows, and I'm always amazed by how quickly some people can react in dangerous situations. These are moments when the amygdala temporarily disables the thinking brain and moves into our primal fight/flight/freeze response. But this is not always the optimal solution. Sometimes, no matter how triggered we feel, our initial amygdala response is outsized and inappropriate for the situation. Author Daniel Goleman coined the term "amygdala hijack" in his 1995 book *Emotional Intelligence: Why It Can Matter More Than IQ*. It means just that: the amygdala hijacks control over your response to a situation, disabling your frontal lobes. Although the hijack needs only about six seconds to dissipate chemically, the effect on your reaction time can be much longer. Imagine how much damage you can do in a couple of minutes when you are **really** pissed off.

The most effective way to regulate the amygdala response is to give yourself several moments to breathe before reacting. Sometimes it

requires a good twenty-four hours, which is something I should have done when I got a crappy email from a colleague blaming me for something that was not my fault. Misplaced blame and condescension are huge triggers for me. I hold myself very accountable, and there is nothing that pisses me off more than people treating me like I'm an idiot. My body went right into balled-fist mode as I read that email. I felt hot all over, and although I should have used that reaction as a hint that I needed time to cool off, I kept rereading the email until I decided to give this jerk a piece of my mind. I typed out a furious response and boom! Off the email went. He absolutely deserved to be served, but more time would have allowed me to craft a more strategic reply. Women are constantly being told we are too emotional, and while I believe that sometimes a little clapback is needed to get your point across, it should be used sparingly. A measured response is usually best.

It's critical to understand the warning signs that we are operating from our lizard brains, so that we can take a breath after we experience an upsetting event and take the time to formulate better responses.

Most of us spend our lives on autopilot. We drive to our destination without remembering any part of the trip. We yell at our kids, mindlessly chat with our partners, spend much of the day feeling anxious, and when faced with an emotion like anger or fear, we act instinctively, but we aren't sure why. That's because many of us don't understand how to properly use that space between stimulus and response. Instead, we simply act.

The first week I spend working with new clients, I have them recall times they felt fear, anger, sadness, joy, anxiety, and frustration. I then have them write down the situation that preceded the emotion, how they responded to that feeling, and where in their bodies they felt that particular emotion. Anger, for example, tends to manifest in a lot of people as a roiling feeling in the gut.[9] Once you can identify that feeling

9 Emeran A. Mayer, "Gut Feelings: The Emerging Biology of Gut-Brain
 Communication," *Nature Reviews Neuroscience* 12 (July 13, 2011): 453-66, doi:10.1038/
 nrn3071.

in the body, you can identify how the feeling travels around your body because that can differ significantly. One woman I worked with realized through this exercise that when experiencing anger, she felt a rush of blood into her extremities that made her clench her fists as if preparing to fight. It's almost like the feeling was traveling into the form of action that she was about to take.

Most people just fire away without thinking when they experience anger, but the trick is learning to observe the anger in your body, without judging it, before responding. This is easier said than done, and it often takes some practice to develop that present-moment awareness. One way I've helped my clients stay grounded when they experience a potential emotional hijacking is through wearables, specifically bracelets that are like a cross between a small rosary and an abacus (sometimes called prayer beads), which allow you to slowly move the beads along a string with your fingers. Another technique is to stop and count all the objects in the room that are a given color, like blue or brown. This exercise is often easier for people, and if you're in public, it's also a great way to maintain your composure without being obvious about it.

I understand people's reluctance to do this because I too was skeptical when I was introduced to these techniques, but when you learn to effectively use them, they are transformative. Once you understand that emotions begin in the body, are the impetus for all decision-making, and who you are is not a product of your emotions, over time you will begin to recognize your feelings before your mind can even become consciously aware of them. And once you know this information about yourself, it becomes so much easier to stop and choose how you are going to react, instead of letting it occur on autopilot.

FEAR AND ITS RELATIONSHIP TO RISK

Our fears extend beyond the basic fear of bodily harm to include learned, psychological fears that can prevent us from experiencing personal growth and taking risks. Management consultant and author Dr. Karl Albrecht identified a model for the five main human fears that encapsulates the different physical and mental fears we face:

1. **Extinction:** Fear for our survival and fear of death
2. **Mutilation:** Fear of something happening to our bodies, including anything that would cause physical harm, from bugs to other humans
3. **Loss of autonomy:** Fear of mentally and physically losing control, feeling trapped, or being controlled by others
4. **Separation:** Fear of rejection, embarrassment, or abandonment
5. **Ego death:** Fear of shame, humiliation, and other things that destroy our self-perception, leaving us feeling worthless

Fear is a useful emotion to work with when it's correctly matched to risk level. Remember that time when you were around people who made you feel unsafe, and you chose not to get in the car? In that case, fear was your ally. You did not take the risk. However, fear-based risk assessments are counterproductive when the fear *exceeds* the actual risk. This is when we start overestimating the potential negative outcomes of a risk because we feel uncertain or afraid. We think our level of fear is equal to the level of the risk, which is untrue most of the time. We struggle to tell the difference between a real threat, when our very survival is in jeopardy, and an imagined threat, which is a fear of something happening in the future that is driven by worry or anxiety.

When we are afraid, we also begin to conflate and confuse the three Ps: **probability, possibility,** and **potential.** We think, therefore it is. We think our fear has a high probability, or likelihood, of being realized, instead of the possibility of multiple outcomes, including positive ones. For example, if you have to stand up and present your part of the business to the board, and you are not a strong presenter, you will envision all the terrible things that could happen, such as stumbling over your words, providing misinformation, and getting roasted by the board for not knowing your stuff. In reality, if you simply take some proactive steps to better prepare you for the presentation, you can increase your chances for success.

Being in a fear state makes our brains work less optimally, so we may rush to judgment or action before considering all our options. Therefore, we must invest the time in cultivating self-awareness of our emotional

state, especially fear, because recognizing how we respond to a situation on an emotional and physical level gives us the ability to choose what we do next. If, for example, we notice that we're spending a lot of time worrying about a future event, we might also notice that our bodies feel restless, wiry, and uncomfortable. Do we want to make decisions from that state, or do we want to be aware enough to change our current state into something calmer and more centered before we respond to the situation? Where our minds go, the energy flows. We have a finite amount of energy to spend, and if we give the lion's share to stoking the fires of fear, we will have less energy for cultivating our new idea, or for the work that makes us feel more fulfilled.

In a 2015 article in *Psychology Today* called "7 Things You Need to Know About Fear," Dr. Theo Tsaousides explained what I thought was a new component to the fight/flight/freeze model, called fright. He posited that when your fear becomes overwhelming, you obsess about negative possibilities but take no action, which can leave you feeling depressed. In other words, because we are so scared of the suffering we associate with these fears, we become experts at threat avoidance. We stay small and retreat into ourselves to feel safe. When we are in this mode, our appetite for risk is low—or even nonexistent.

I recognized a long time ago that I was operating from a place of fear when I kept talking about certain problems, but I never did anything to change them. This happened time and time again when I found myself stuck in an unhappy relationship or an unfulfilling job. I would complain to anyone who would listen, but day after day I would get up and put myself through the same thing all over again, even though I knew that I deserved better, and that the situation wasn't right or healthy.

This can happen for a lot of reasons. Sometimes we're worried that we'll make the wrong choice, so we choose to do nothing. Sometimes we were burned the last time we tried something new, so we're afraid to try again. Sometimes we lack the confidence or we're just afraid of looking stupid. I know it sounds crazy, but a part of us can actually become *addicted to the suffering*, and that becomes the new normal. Over time, we can begin to forget that we are worthy and no longer believe there is a way out. We get stuck in a downward spiral and develop a victim

mentality, where we start to believe everything is happening *to* us. That takes all the power out of our hands because we no longer feel like we have a choice. It's a very childlike outlook on the world.

Meanwhile, we march through our days on autopilot, without stopping to consider how much our unhappiness is detracting from other areas of our lives. The irony is that the misery we're experiencing in the present is almost always worse than the scariness and uncertainty that would come from removing ourselves from the unpleasant situation, but we rarely stop to think of it that way. When operating against fear, it's easy to forget that we have agency and a choice in the matter.

RECOGNIZING OUR SELF-DEFENSE MECHANISMS

All of us feel anxiety on some level. According to Oxford Languages, anxiety is defined as "a feeling of worry, nervousness or unease, typically about an imminent event or something with an uncertain outcome." Anxiety moves into disorder territory when it becomes chronic, excessive, and starts to impact everyday life. Though anxiety can become chronic and require medical intervention, for many of us it is more temporary or situational.

I was once in a mindfulness training course that was focused on peak performance. The teachers performed an experiment with us where they sat us in a semicircle and then threw an apple to us one at a time. We were asked to catch the apple and throw it back to the teacher. When it was my turn, I grew anxious, and my mind raced. *Everyone else has caught it, what if I'm the only idiot who gets hit in the face with an apple?* Luckily, I caught it, but I had never focused so hard on such a simple exercise in my life and felt immense relief when it was over. During the exercise debrief, I was happy to find out that everyone had felt anxious. We had all attached some form of self-worth to our ability to throw and catch a stupid apple successfully. We attached *meaning* to it. So, if the simple act of catching an apple can cause even a mild amount of stress, imagine what our brains can do when the stakes are real, and much higher?

Anxiety and fear can produce a similar reaction in the body, but while fear comes from a response to an immediate danger, I think of anxiety

more like a blanket covering an emotion that we may not be able to identify in the moment. It's usually something we subconsciously process to avoid suffering, and that's where our self-defense mechanisms come into play.

Identified by Sigmund Freud as early as the late 1800s, the concept and definition of self-defenses have continued to evolve ever since. They are one way we try to reduce our own anxieties and fears, and many of us have a well-ingrained and preferred response mechanism to fear and anxiety—my personal favorite is turning against myself, usually by overeating, self-blame, and criticism. My parents have had a lot of medical challenges over the past few years, including one particularly bad spell in the spring of 2020. As great as I am during a crisis for everyone else, I am terrible at taking care of myself. Every night after leaving the hospital, I came home and freebased vodka and Froot Loops. That was absolutely not what I wanted to be doing, yet I chose to avoid dealing with the really hard feelings and turned to food and alcohol as a way to numb myself. As a society, we are encouraged to become numb, especially since the dawn of COVID-19, when watching more TV and drinking more wine became synonymous with self-care.

It's not just food and snacking; sometimes I turn away from myself by giving into my desire to people please instead of creating better boundaries. My therapist calls this "tend and befriend," while other psychologists refer to it as "fawning." It's yet another option in the fight/flight/freeze trauma response model, in which you turn away from your own needs to take care of someone else. Sometimes we literally disconnect from our own feelings, which we see as less desirable, so we don't jeopardize the relationship. I can struggle with feeling unworthy, and usually go well above and beyond for others because I just can't accept that I'm good enough or that I've done enough to secure my place in the relationship. Women contend with this more than men because it is expected that we will martyr ourselves to keep the people around us happy.

In the moment, our self-defenses can help us deal with feelings of fear or anxiety, but they allow us to ignore the root issue, which will continue to plague us until we decide to examine that underlying cause of the

anxiety or fear. As research and thinking evolves, the identified self-defense mechanisms evolve as well, as does the categorization of them as unconscious versus conscious, negative versus positive, and whether they exist on a continuum. Here are some examples of common self-defense mechanisms. Do you see yourself employing any of these when you feel fear or anxiety?

- **Denial:** You convince yourself that the unpleasant thing or feeling is not even happening.
- **Displacement:** You take out your anger on the wrong target. This can include turning it against yourself, like when I'm mad or scared about something, and I resolve it by eating an entire box of Girl Scout cookies.
- **Intellectualization:** You try to rationalize your way out of feeling. This is another favorite of mine. I look for the reason "why" I do or feel something, rather than just accepting that I do feel that way and learn healthy ways to feel the actual emotion.
- **Projection:** You place your negative feelings and thoughts onto someone else, like when I'm pissed at my colleague but then act like an asshole to my husband. (Sorry, Mike.)
- **Rationalization:** Have you ever found yourself trying to rewrite history when you made a poor decision and things didn't turn out as expected? This is either related to "all things happen for a reason" thinking or denying your true feelings and thinking something like, "I didn't want that anyway."
- **Regression:** You react to a situation like you would have when you were younger, usually through name-calling, shutting down, or throwing a mini tantrum.
- **Sublimation:** Some call this a positive mechanism, though I would consider it more neutral: it's when you take a negative feeling or situation and direct your energy toward something healthier (e.g., attending a kickboxing class to get your anger out versus going nuts on everyone around you). It may help you channel your difficult feelings into positive action in the moment, but it may also be a distraction from a reality.

These are just a few of the many self-defenses that have been studied. Familiarize yourself with them, and you can become an expert on your own ways of avoiding threats and feelings. Psychological thinking about self-defense mechanisms evolved into exploring them through a larger lens, seeing how they related to "coping strategies." But what are most women trying to defend themselves from?

THE MOST COMMON FEARS

There are many reasons to be fearful, but I have noticed a pattern in many of my clients, and the top three fears I encounter most frequently when coaching women are **fear of failure**, **fear of humiliation**, and **fear of not being good enough**.

1. FEAR OF FAILURE

One positive outcome of our collective obsession with entrepreneurs is the concept of embracing failure. Even from an investment perspective, entrepreneurs who have already tried and failed at one business can earn more trust and funding in their second venture. Seasoned VCs like to see that the person has already built some experience and grit and learned lessons they can take into the second venture. As is typical in American culture, we went from abject fear of failure to borderline romanticizing it, so let's try to bring it back to center for a moment.

No one likes to fail. Sometimes things go way off the rails, and life explodes in our faces, leaving us bereft and exhausted. It's a knock to our confidence and can start to sow seeds of self-doubt that can be hard to overcome. There's a reason Theodore Roosevelt's famous "Man in the Arena" quote resonated so strongly with people, and I think women in particular. This line is our call to risk-taking: "If he fails, at least he fails while daring greatly, so that his place shall never be with those cold and timid souls who know neither victory nor defeat."

I work with many women who feel stuck, but it's not typically because they feel they have failed. They feel stuck because they *anticipate* failure. They are me, at eight years old, climbing up the ladder for the high dive, standing on the edge looking down at the water, and being so gripped

by fear I could hardly breathe. Rather than stay in that uncomfortable feeling long enough to get centered, they, like my younger self, fall prey to the shouts and taunts of the kids in the pool. They shrink back from the edge and climb back down the ladder, only to try again next week. This repeats until we finally stop trying.

At the root, we fear how we and others will think of us *after* we've failed. This fear can stem from a variety of causes, including your family. Maybe you came from a long line of high achievers, and you were pushed as a child to be the best at everything: star athlete, star student, star child. When you did fail, and your parents expressed their disappointment in you, it made you feel bad about yourself, and you began to attach your self-worth to achieving goals, or status. Perhaps you've had previous failures that were so catastrophic that they caused financial and emotional repercussions you are still contending with today. Many of us fear failure, but it is really uncertainty we fear. When there are multiple futures and outcomes at play, we can sometimes react to the unknown as a threat and avoid taking action unless we can be assured of a positive outcome.

Over the past several years, a lot of messaging targeted at women centers around perfectionism, meaning that you only take risks and try things you know you can do successfully, or that you only put something out into the world when it is flawless. Many of us, myself included, do not identify as perfectionists, but as people who care deeply about their work and pride themselves on quality. But I've come to realize that I was putting impossible expectations on myself to do everything perfectly, at home and at work. That made me put the same impossible standards on those around me and then become deeply critical of myself and others when they didn't meet my expectations. My ego loved nothing more than to be judge and jury of how well other people were doing at life.

So much of the fear of failure happens only in our minds. It's the adult equivalent of fearing the monster under the bed, so we never let our feet hang over the edge. I find that the best way to move through this fear is to wrestle the monster out from under the bed to see what you're really dealing with. When you take this kind of risk, you make the unknown known pretty quickly. If you fear launching your new business because

you don't think anyone will buy your product, then it's best to find that out as soon as possible, so you can figure out how to make your product more attractive to your customers.

I stayed in fear for a long time while writing this book, wondering if anyone would care about what I had to say. That's when I realized I had to change my *why*. I am writing the book that I need to read right now, which means it only has to help me, even though I hope it will help many more women. We talk to ourselves more than anybody else, so paying attention to our self-talk is one of the most important ways to work through our fears, especially the fear of failure. You don't have to do it entirely on your own. If you find yourself struggling, there are some tools that can help turn your typical constant stream of negative chatter into something positive and helpful.

ADOPT A CHARACTER

During mindfulness training, a teacher recommended that we adopt a character to be our internal voice. We went through an exercise where we developed that character into a compassionate coach, either using a person we already knew or by imagining how a well-known person might talk to us. Sometimes we journaled in the voice of this coach and wrote letters to ourselves in their voice as a way to have a dialogue with a friend who wants the very best for us. If you're not naturally good at journaling (I'm not), try having an imaginary conversation with your compassionate coach (thank you, Betty White). When you think about how a person who cares about you would respond to your problem, it's soothing, and it brings your brain and body into a calmer space so you can work through the issue.

MIRROR WORK

This is a technique that many people find uncomfortable, but I've come to prefer it. Whenever I have a tough conversation coming up or a meeting that I'm afraid will not go the way I want it to, I stand in front of a mirror and talk to myself. Before a difficult conversation I had to have recently, I gazed into my bathroom mirror, looked myself in the eyes, and said, "Megan, you are going to do great in this conversation. You are going to be strong, articulate, and controlled. You will walk away from today knowing

that you said your piece, and that you did it elegantly and respectfully." And guess what? I was right. That was exactly how it went. Looking at yourself in the mirror with intention can be intense, but nothing compares to seeing you assure yourself with steely determination that you will be OK and knowing that you've got your own back. It's my most effective go-to when I'm afraid.

THE 5 WHYS

I'm a middle child, so I want to be liked and needed, and the thought of being judged negatively by others is soul crushing. This is why I was always a lurker on social media instead of a prolific content creator. I was aware of this tendency in myself but didn't understand the reason behind it, so I had to force myself to think deeper about what I was really afraid of. It doesn't matter what the problem is—if you can get down to the root cause, you will uncover an opportunity and a solution.

One of the oldest and easiest problem-solving tools in business is Sakichi Toyoda's (the founder of Toyota) **"5 Whys."** Essentially, you state your problem, and ask yourself "Why?" five times. The idea is that each "why" will get you closer to understanding the root of your real issue.

THE WORST-CASE SCENARIO

I like to put a twist on the 5 Whys and ask myself, "What's the worst-case scenario?" Let's try it with an example from when I was twenty-eight, when I was deciding whether I should stay in my job or quit and travel the world.

Problem statement: *I want to quit my job and go travel, but I'm afraid to do it.*

1. *What's the worst-case scenario?*
 I will have no active income and no job to come back to.

2. *What's the worst-case scenario?*
 I will come back with credit card bills, no job, no place to live, and I will be very stressed out.

3. *What's the worst-case scenario?*
 I will be couch surfing, unable to find a corporate job, have to work for an hourly wage, and feel miserable.

4. *What's the worst-case scenario?*
 I will have to move in with my parents while I look for a new job.

5. *What's the worst-case scenario?*
 I will live with my parents for longer than I want to as I continue to look for a job.

Suddenly the worst-case scenario didn't seem so bad, so I did decide to quit my job and travel. And it's a good thing that I didn't dread the outcome because that worst-case scenario actually did occur. I had to move into my parents' apartment in downtown Chicago, and I wound up having to work in retail while looking for a job at my previous level. And to be honest, parts of it were great! I developed a really fun and close bond with my parents as I went on dates with my mom around the city and rode bikes with my dad. They were happy to have a break in their empty nest routine, and I had incredible adventures on my trip and returned home with stories I could share for the rest of my life. Not to mention a huge dose of self-confidence that I developed while navigating my way around India, Southeast Asia, and many other parts of the world. No regrets! On those days when I felt like a failure at my hourly retail job, I reminded myself that I was building a new life, and that the trade-off I had made was worth it. I would likely never have the freedom to travel that long again. A short time later, I moved across the country to California, after taking a job that doubled my before-travel salary.

The takeaway is this: when you start asking yourself, "What's the worst that can happen?" you not only find that your mind has built up that worst case to be ten times bigger than anything that could ever manifest, but you will also set it searching for solutions to all those worst-case scenarios.

2. FEAR OF HUMILIATION

Sometimes the fear of embarrassing ourselves keeps us stuck; I have held this fear closely since childhood. We've all experienced those moments that feel unrecoverable and threaten to vanquish our entire being right where we stand. Early experiences with humiliation can keep us resorting to our defense mechanisms, but sometimes embarrassing ourselves is simply unavoidable.

I was in year two of my own consulting business when I landed a huge client. I had already been working with them for a year when my client contact left the organization, and a new leader was hired to replace him. That's when I began negotiating with the executive team on my contract renewal. On the morning of my meeting with this much-talked-about leader, I woke up with a crippling migraine, a chronic condition I have dealt with for more than twenty years. When I get migraines that break through my medicine protocols, they are completely debilitating. This was one of them.

I was due to fly home about an hour after our meeting, so I spent the morning hidden in one of the company's many "nap rooms," trying to will the headache away, to no avail. I had to put on a brave face and take the meeting. And it went great ... at first. The leader was an active guy, so he wanted to walk and talk instead of sitting inside an office, which at least gave me something to focus on other than the throbbing pain in my head.

Our hour was nearly up, and I thought I had dodged a bullet. We were on our way back when he decided to sit on a bench with me to close out our time together: a bench in the hot, blazing sun (a huge migraine trigger for me) that was twenty yards from hundreds of other employees who were enjoying lunch outside. That's when it hit me: the deep, rolling nausea that always accompanied breakthrough migraines. I held it together for another ten minutes, and then we were done. Phew! That was close, but I made it! But as he walked me back to the building, without warning I vomited everywhere. All over myself, over the bushes, and over his designer shoes. After the initial spasms were done, I raced inside and hid in a bathroom stall with my luggage, where I changed my clothes, brushed my teeth, and weighed my options.

I had two choices: exit the building as quickly as possible, fly home, and never see him again, or face the complete shit show that had just occurred. I chose the latter, and I think largely that was because I had become so much more compassionate with myself over the past few years. I knew there was no situation I could not recover from. So, I took the risk of sitting down with him, telling him about my medical condition, and apologizing for ruining his shoes. I'm glad I did, because when I decided to be vulnerable with him, he opened up and shared his own experiences with chronic illness, and we forged a special bond that has lasted for years. He turned out to be one of the loveliest and most genuine leaders I have ever had the pleasure of working with. Not only did we form a great friendship, but we went on to partner together on great work.

3. FEAR OF NOT BEING GOOD ENOUGH

For women, this fear is particularly insidious, because it keeps us small. In my experiences with my clients and even other peer leaders, it is usually cloaked in something that looks like anger, blame, or inaction. Most of us have never considered that feeling unworthy is at the root of our fears. And we are inundated with messaging every day that tells us we actually aren't good enough; the paltry representation of women in all spheres of power, as lead actors, headlining comedians, politicians, and of course CEOs, makes succeeding at the highest levels feel unattainable. The completely unrealistic images of beauty, diet culture, the billion-dollar self-help industry—all of them squarely targeted at women—don't help either. We keep iterating different versions of ourselves, thinking we are one mantra or thirty-day cleanse away from attaining happiness, confidence, and success. But we self-development junkies are just chasing self-acceptance. And because we can't accept ourselves, it hurts even more when others don't accept us for who we are and what we bring to the table. That kind of rejection leaves us wondering if we really are as good as we thought we were.

I had a recent conversation with a return coaching client who is brilliant and found herself taking huge career leaps in quick succession. Then, the first year into a well-funded middle market company, she found herself back on the job market sooner than she anticipated. She was considering

launching her own business and had been entertaining multiple great offers from well-regarded brands, so we explored her options. I felt that she was gravitating toward roles that were diametrically opposed to what she told me she was looking for in her next move.

As we peeled back the layers, I realized why. She had internalized the narrative, which had been passed down to her from previous executives, that she still had some learning to do and experience to gain before she could move into top leadership. I finally told her straight out, "You. Are. Ready! Stop telling yourself you have these imaginary boxes to check. Yes, you will still learn, and you will fuck some things up, but that doesn't mean you aren't ready to lead without being under some other leader's wing. I know you're good. You know you're good. There isn't anything that has been thrown at you yet that you couldn't master. Don't you think you're ready? I think you know you are, but you're afraid to claim it out loud."

I could see in her eyes that she knew she was ready, but she had been waiting for someone to tell her that she had reached her arrival point, and no one had. Seconds later, she told me about an amazing opportunity that was a dream job for her, which involved leading at the very top position. She hadn't mentioned it because she hadn't let herself dream that big yet, but as soon as I saw the fire in her eyes, I knew she had to go for it. She knew it, too. To drive the point home, I made her an official-looking certificate stating that she had reached, by the power of the universe, her arrival point.

All of us have some kind of story etched into our subconscious that keeps us from taking chances. This last most common fear requires thorough and radical personal inquiry into our beliefs about ourselves, our capabilities, and the world around us. Don't wait for someone else to tell you that you're good enough. You have to be your best champion.

Regardless of your particular fear, the way you think about, assess, and overcome your fears is the same.

OVERCOMING FEAR

I have a friend who is a fire captain. While at dinner one night with her and her husband, a California Highway Patrol (CHP) officer, I asked them both how they were able to keep putting themselves in high-risk

situations day after day. How they could overcome the fear of approaching a burning building or a bad car accident on the highway. Both pointed at their training. Not only were they each heavily trained and paired up with senior firefighters and CHP officers, but they trained often, and in my friend's case, with fire gear on, so that it became second nature to her. She got used to operating while wearing up to seventy-five pounds of gear on her small frame. Firefighters also get a lot of exposure therapy through "burn boxes," which weed out newbie firefighters. This is just what it sounds like: they put on their gear and step into a box while a large fire burns around them, so they can feel the heat on their faces and feel their knees start to burn. The trainers want them to see what it will be like before they show up at a live fire. This is crucial, because once on the job, they not only have to summon their courage during every major incident, but they must also temporarily quiet their own feelings to help someone else. Over time, their decision-making becomes more automatic, and with every successful outing, they gain more confidence. That is what working with fear should look like for all of us: it takes practice. But there are some tools available that can help you step up your game.

1. OODA

Soldiers, for example, need to employ compartmentalization, where they focus only on what they are doing at the time. One moment they are on a dangerous mission, and the next they are on a video call with their families. Although this can result in negative outcomes down the road, such as PTSD and other mental health issues, the soldier's survival literally depends on their ability to stay clear-headed during battle, so that their emotions don't take control and put them and their fellow soldiers at greater risk.

Much of this is taught through exposure therapy that tests them rigorously in various uncomfortable and frightening situations. A friend and work colleague is a retired USMC lieutenant colonel and one of the calmest people I've ever met. We tease him by calling him a robot because he is unflappable. He completed half a dozen combat deployments, flew CH-53 helicopters, and became a special weapons and elite tactics instructor while leading squadrons of 300-plus people in battle. CH-53s

are huge helicopters used to transport soldiers and equipment in combat, which means they are a large target.

I questioned him frequently about how he could stay so calm in the face of danger and then be able to switch gears smoothly when necessary. He explained how Marines undergo intense training to make sure they can handle many kinds of stressful situations without triggering their fight or flight response, including escaping from a helicopter that had crashed into the water, undergoing drowning simulations, and flying under simulated pressure. He learned to compartmentalize, and often employed the four-step **OODA** loop decision-making process, which was developed by US Air Force Colonel John Boyd after his experiences in the Korean War:

1. **Observe:** What do you know about your environment right now? What are the facts?
2. **Orient:** Consider your options, based on what you have observed and on your prior experience. Don't wish things were different— just deal with the reality of your situation.
3. **Decide:** Choose the option you think is best and most important for this moment.
4. **Act:** Make your move.

This is one way the Marines prepare to move faster than the enemy, and when the enemy anticipates their action, they often say, "He got in my loop." As it was explained to me, the OODA model is about taking initiative, and if you make faster decisions than the other person, they are in a state of reactivity while you are controlling the environment. Speed is an important component of this model. I asked my colleague how he would explain the importance of time pressure in decision-making to people who might not need to act immediately, and who can therefore get stuck in indecision: a founder considering whether to hire someone to fill a new position, or perhaps a VP who wants to be a CMO but must leave her current organization to do so. He said the key to this kind of confident decision-making and risk-taking is that making decisions quickly allows you to "move forward with purpose," knowing

that even a mediocre decision is better than no decision at all. The more you get used to moving through fear and deciding, the more you start to trust your decision-making intuition, and you can then graduate to making more complex decisions quickly.

We can't all go out and undergo extensive military training, and compartmentalization is not always a good thing, but we can all benefit from some of these techniques. The OODA loop helps you make the best possible decision in the moment, rather than getting hung up on trying to make the *perfect* decision and ending up never deciding at all. The reality is that we can't know every factor in a risky decision. We are always forced to decide based on imperfect information, but this method allows you to remain in the driver's seat by making the best possible decision you can in the moment with the information you have. Even then, you will sometimes make the wrong decision. Just don't let that stop you from taking further action.

2. CREATE A MISTAKE RITUAL

Being married to a veteran, I understand the darker side of this training, but I also believe we can learn much from the military when it comes to coping with fear and gaining confidence in ourselves. The concept of having "no memory" is another valuable one. That means if you make a mistake, rather than letting it get in your head and put everyone at risk, you immediately let it go and start over with a clean slate. Recovering from missteps is a huge part of building confidence in the face of fear because it's so easy to get stuck in a thought cycle about all the things you could have done differently or all the problems that could result from your mistake down the road. This pattern of rumination only increases the probability that you might mess something else up because you're not focused on what you're doing.

In that mindfulness training that I mentioned earlier in the chapter, I also learned about mistake rituals, which I have since passed along to many of my own clients. The idea is very simple: when you screw up, you do something playful or lighthearted to reset your mind and help you recover, so you can get your mojo back.

I took this class with a bunch of professional athletic coaches, so I got

to learn about some quirky rituals their players used. There was a hockey goalie who, after every mistake during a game, would squirt the water from his water bottle up in the air. A soccer player would mimic flushing a toilet on the pitch before the next play. This was how they cleared their minds to prevent mistakes from affecting their performance for the rest of the game.

Whenever you make a mistake or something embarrassing happens, you become anxious, upset, and fearful. You might be afraid that what you just did will cause you or others harm, or you might fear what people might think of you. It's easy for our brains to slip into a negative loop. You can't function or find a good solution when you're in that state. However, you actually have more control over your mindset than you realize. You can stop ruminating and shift into a state that I call *positive reaction*. Think about it like this: once that mistake or embarrassing event occurs, it's in the past. In this new moment, you are fine. What lingers is just a thought and a feeling in your mind—both of which are in your control. The mistake ritual is a way to trick your brain and body into clearing the slate—emotionally and physically—for new, more helpful thoughts and emotions.

Find a mistake ritual that works for you. It could be excusing yourself to go into the bathroom at the office where you can dance like Elaine from *Seinfeld*. It's always good for your mistake ritual to involve movement because it's not only your mind that needs to be reset. Your body has memory as well, and it can store that negative energy. Simply by moving your body, you can help release that energy. And the bigger the mistake, the more ridiculous your mistake ritual should be. If practiced effectively over time, this ritual can begin to change how you process negative events, so you can build resilience, stop beating yourself up, and bounce back from your mistakes.

3. OPEN UP A MENTAL BANK ACCOUNT

Start to stockpile all the great, positive, and successful moments of your life in your mind so you can draw from them later when something shitty happens. You do this by spending time savoring the wins in your life, reflecting on the things that went well, and enjoying your successes.

4. PRACTICE SELF-COMPASSION

Another method is talking to yourself with compassion in the moment as a way to separate yourself from the negative experience and feeling: "Wow, Megan! That meeting you facilitated totally bombed when those two leaders started arguing, and it was so uncomfortable to sit in. Thank God it's over, and you never have to do that again." This helps you realize that you aren't a fuckup; it's the situation that got fucked up.

These are all ways to generate enough goodwill to change your perspective in the moment from pessimism to optimism. If you can master these techniques, you can move past your mistakes or uncomfortable moments and get safely to the other side.

A CHECKLIST FOR WHEN YOU ARE FACED WITH FEAR

People who know how to work with fear versus being consumed or paralyzed by it are typically good at the following four key things, so the next time you feel overwhelmed with fear, these are the steps you should implement:

1. **Self-Awareness:** The fear will never go away, so don't waste your time trying to mask or ignore it. Instead, learn how to identify the fear and the feelings that come with it on a cognitive, emotional, and physical level.
2. **Separation:** Understand the difference between I am afraid and I am experiencing feelings of fear. You are not the sum of your thoughts and feelings. If you can put distance between you and whatever is about to put you into an emotional tailspin, this "sacred pause" can give you the psychological space you need to move on to the next step.
3. **Self-Management:** Once you can properly identify your emotions, it becomes easier to work more productively on controlling your responses to them. First, be still. Let the emotions come, and then let them pass through you. Don't try to prevent them, and don't knee-jerk respond to them. Just be with them. When you're ready,

move forward and act; don't let fear paralyze you into getting
stuck where you are.

4. **Recovery:** Consider this a contingency step. You're not always
going to make the right decision, but you can't allow that to
create more fear that prevents you from taking further action
and making future decisions. Learn how to build resilience by
practicing faster recovery from errors and missteps, and you will
stay one step ahead of your fears. You do this through positive
self-talk and making sure you practice good mental and physical
self-care.

You aren't going to suddenly wake up one morning and find that
you've transformed into a bold and fearless version of your former self.
It's a daily practice that, over time, will help you build up your risk-taking
muscle and achieve your potential. Successfully navigating through
your fear is one of the best ways to build your self-confidence. Even if a
situation ends poorly, you can be more confident knowing that you got
yourself through it. We are too quick sometimes to dismiss our record of
fighting fear. Let's put that skill to the test.

CHALLENGE

Fears come in all shapes and sizes, and my fears aren't necessarily
the same as yours or anyone else's. What comes easy for you
might be difficult for me. Fears can be big and small, but for the
time being, let's start small.

What are some small fears you might be confronted with
throughout the day? I'm not talking about phobias—more about
times when you find yourself out of your comfort zone. Maybe it's
a fear of asking for help or speaking your mind. Maybe it's a fear
of public speaking. Maybe it's a fear of saying the wrong thing or a
fear of what others might think about an idea or a suggestion you
have. There are countless examples. Pick one, and sometime today
make it a point to step out of your comfort zone and face that
particular fear. Speak up in a meeting when you would otherwise

be silent or strike up a conversation when you would normally fade into the background. It could be something as simple as opening up to your significant other and being vulnerable in a way that you had never been before. You can start small, but you have to start.

After you build confidence fighting a small fear every day for a week, step it up a notch: think about one goal you keep talking about but haven't made any measurable progress toward achieving. Now imagine yourself taking that risk. Work through the "What's the worst-case scenario?" exercise and the "5 Whys." Then decide if you can take a small step toward your goal.

CHAPTER 2: INTUITION
LEARNING TO TRUST YOURSELF AGAIN

"The psychological rule says that when an inner situation is not made conscious, it happens outside, as fate."

CARL JUNG

AS A WOMAN WHO HAS TRAVELED EXTENSIVELY around the world, I've learned that if you want to do anything interesting and exciting, you must learn to put your fear into perspective.

When my sister Tracie and I took three weeks to travel throughout Panama, we found ourselves in plenty of fearful situations. At one point, we wanted to go snorkeling with sea turtles, which meant we had to hire two local men to take us out to the best spot. It wound up being a phenomenal experience, but it involved getting in a boat with two strangers and trusting them to take us out into the middle of nowhere.

We found ourselves in a similar situation when we had to get into a tiny canoe with another set of strangers to row us out to the small, remote island off the peninsula of Bocas del Toro, where we had rented a house with a private beach. It was night by the time we left the mainland, and there wasn't another woman in sight, so we already had our guard up. We had no idea where we were going and had to trust the two guys with bloodshot eyes steering the canoe, so it was a nerve-racking experience, but we made it safely to the other side and got settled into our house for the night.

First thing the next morning, my sister and I took a walk through a little forest to get to a beach we had heard about. We were about thirty feet apart, just taking in the trees and the water. Out of nowhere, two men appeared, parallel to us, but closer to the road. The suddenness of their appearance immediately put us on guard. Without speaking, we quickly picked up our pace and started heading down toward the shoreline, where we would be out of the woods and onto the beach. The men also sped up, one moving closer to my sister, and one closer to me. My body immediately filled with a feeling of terror, and my hand closed around the dagger I always carried when I traveled. *Fight!* My sister yelled out to them not to come any closer. After several tense moments of half walking, half running to the beach with them in pursuit, we burst out of the woods and found ourselves amidst a group of tourists. The men retreated into the forest.

I don't know what they wanted with us, but I knew it wasn't anything benign. We hadn't seen them coming, but the forest was fairly open, which meant that they were deliberately hiding before they stepped out from behind the trees. They acted without speaking but seemed to have a plan because they changed directions to form a tighter box around us, so that we would move closer together. They weren't smiling, and they didn't respond when my sister called out to them. The entire encounter lasted mere moments, but in that short time, my brain and my sister's brain made a thousand calculations, and without discussing it, or even consciously thinking about it, we knew what we had to do. *Survival! Safety!* Our thinking brains were completely overwritten by our amygdalae, and we ran. *Flight!* That was true fear, and that was our bodies responding exactly the way they were designed: for self-preservation. All of it instinctual.

Instinct is something we're born with, and it's absolutely essential when you are in grave physical danger. Picture wild animals either hunting down prey or racing to escape their predators—that's instinct. They aren't pausing to consider their options. The animal kingdom is instinct at its finest, and it works the same way for us. It may be limited to basic survival situations these days, but it's immediate and occurs on the subconscious level. Our body is already set up for these moments.

What separates us from the animal kingdom is our intuition, which is a more evolved version of instinct.

When I was a teenager, I was obsessed with Oprah's daytime talk show. One guest who made a real impression on me was security expert Gavin de Becker, who had written a book called *The Gift of Fear*. Reading that book was a life-changing experience for me. The book featured a series of stories from women who had been attacked or harmed in some way, but when they reflected on the incident afterward with de Becker, they had seen small indicators that something wasn't right before the violence occurred. Their intuition had warned them, even if they hadn't paid attention to it at the time. The purpose of the book was to teach women how to listen to and trust their own intuition, while also being able to recognize these precursors to violence.

We are all born with the gift of intuition, and a sense of "gut instinct." With more than one hundred million nerve cells, sometimes the gut is even described as the first brain. The word "intuition" comes from the Latin verb *intueri*, which means "to consider." If instinct derives from the amygdala, intuition derives from the thinking brain or the frontal lobes, as well as our gut brain. It's what helps you determine when you should act or give something more thought. That can occur quickly, but just because we have intuition, that doesn't mean we can always properly identify it.

There is a lot of competition for our attention, inside our heads and out. Cultural messaging, our own unexamined thoughts, and the thousands of other messages we are bombarded with every day keep us from tapping into our own internal knowledge. This is why self-awareness is so crucial. Intuition is cultivated and honed over time with each new decision and experience, but self-awareness is what keeps it strong and allows you to trust it. You must be able to recognize your own emotions, how you respond to them, and how that impacts the people around you.

HOW WE TURN AGAINST OURSELVES

I am not sure exactly when I stopped listening to my intuition in favor of worrying about what other people thought of me. But by the time I was seventeen I struggled with honoring my gut instinct. Raised by a

no-nonsense, Brooklyn-born mother, I had a natural propensity to distrust people out of the gate, but my parents also prized politeness when raising myself and my sisters. As I got older, I realized that in the name of civility, I had stayed in many difficult and even dangerous situations. I chose to ignore my intuition rather than make someone else feel uncomfortable.

This was reinforced during my first job out of college. I studied journalism, and after realizing that I didn't want to slug it out in rural markets doing stories about the state fair, I started working behind the scenes, doing video production and scripting for the state of Georgia. I worked with men who were my father's age. They smoked and drank, swore like sailors, and kept shit from their wives. Despite the differences between us, I got along well with them. They didn't treat me like I was special, and I got to experience what life in a perpetual men's locker room was like.

This was back in the 1990s, when I was in my twenties, and the goal then was to fit in. You were considered a successful woman if you had the respect of the men you worked with but didn't require them to change. Now that sounds so archaic and, well, *wrong*. That meant having to endure less than respectful conversations about women, but that wasn't the worst of it. One man regularly pulled his penis out just to shock everyone, and my boss once wrote me an email expressing that he wanted to sleep with me. He put it in writing! I think I first read it at work, which was especially horrifying since we all sat in the same set of offices. He was married, had horrible body odor, was not attractive, and was at least twice my age. Still, he felt free to send that to me, his employee. I went home feeling ashamed.

As women, we spend years building skills that allow us to contribute and add value to our team, and what we get in return is some version of, "I want to have sex with you." After reading that email, it felt like all I was to them was window dressing. I wasn't there for my talent; I was there so they could gawk at me. Did they all think that, or was it just him? Did any of my contributions even matter?

Even though it was clearly his issue, I wondered what I had done that emboldened him to talk to me like that. I took smoke breaks with him—did that make him feel like I was interested? He did confide in me

that he had a fetish for seeing women smoke. He was really kinky and weird about it. Whatever the reason, what was I supposed to do now? I remember forwarding the email to my mother for safekeeping in case I needed to "use it one day." It never occurred to either of us that I should be using it the very next day to get him fired. Nope, I thought I was the one who had to leave, and I did. I knew I'd never be comfortable again after that email, and I didn't want to go through the embarrassing process of reporting him to HR. Back then, he wouldn't have been fired anyway, only reprimanded, which would make sitting in the dark editing bay with him even more uncomfortable.

Looking back, it's easy to be angry at myself for not standing up for my boundaries, but back then, at twenty-three years old, all I knew was that women who complained became targets. And more than anything, I didn't want to be treated like I wasn't on the team. That meant I had to turn against my own intuition and not rock the boat of the workplace.

That experience was just the first chink in my armor. I went on to contend with many more senior male leaders and clients who tried to corner me at parties or test the waters for clandestine affairs, with absolutely no interest from me. That just made me work harder, because I kept thinking that if I could outpace everyone else on a team, my work would make me more respected, and I would finally be treated as an equal. I was great at what I did, and because I didn't want any special treatment, I worked especially hard to act more like the men who surrounded me; hardened, tough, and confident. Eventually, I had no work/life boundaries. I was resentful of everyone around me for "making" me do work I didn't want to do, and I devolved into a working style fueled by thoughts of anger, defensiveness, and revenge. I was coiled up like a cat, ready to pounce at any moment and had traded my more evolved judgment for misguided instinct. If I had attempted to listen to my intuition, it would've been like turning a radio dial where every channel sounded like static. I went from being on autopilot at work to the bar with my friends, numbing any chance of finding my internal compass again.

My experience isn't unique. Many women lose touch with their intuition over time, and the process starts when we're very young. A visit to a big box retail store will show you how young the "pink and blue"

divide begins, so even our interests are curated from an early age. Some studies show that girls begin to doubt their own intelligence as young as age six. In a 2018 study by marketing research firm Ypulse and *The Confidence Code for Girls*, researchers found that confidence levels for girls drops by 30 percent between ages eight and fourteen. Three out of four teenage girls worry about failing, and the percentage of girls who say they "are not allowed to fail" goes up by 150 percent between the ages of twelve and thirteen. The same phenomenon does not occur among boys of the same age—and some studies even report levels of outsized confidence. The age at which kids think women can be as smart as men drops dramatically around first grade.[10]

The systemic issues of nurture versus nature that work against women and girls begin so early that they can sneak up on us, like they did with my own daughters when they began to worry about their appearances and doubted their abilities at an age so young it broke my heart. In school, as a young girl, intuitive attempts to get excited or be spirited get stamped out of us in favor of being quiet, obedient, and pleasing others. "Boys will be boys," but girls better fall in line. We're taught "stranger danger" at a young age, and we start to recognize who the creepy adults are, even if we can't verbalize why we don't want to be around them. We're taught never to walk alone at night and never to abandon our girlfriends at a party. But what never gets talked about is the systemic issue, and we never get an explanation for how, or even if, the world is fighting to protect women and girls. Rather than hold victimizers accountable, we are expected to carry that additional burden throughout our lives and hone our survival skills. But while we're being taught that we need to be warriors and defend ourselves, we're also being told that we must ignore our intuition in favor of being polite, agreeable, empathetic, and the caretakers of the community. Go ahead and take a Krav Maga self-defense course and learn

10 "The Confidence Collapse and Why It Matters for the Next Gen," The Confidence Code for Girls and Ypulse, accessed July 8, 2022, https://static1.squarespace.com/static/588b93f6bf629a6bec7a3bd2/t/5ac39193562fa73cd8a07a89/1522766258986/The+Confidence+Code+for+Girls+x+Ypulse.pdf

how to disembowel an attacker, but make sure you are home in time to cook dinner, help with homework, and drive your elderly mother to the doctor.

Over time, all these mixed messages solidify into misguided beliefs that we internalize and program into our autopilot function without ever examining or questioning them. We then carry around this layer cake of shit throughout our lives, doing and thinking the same things again and again because it's what we've always done and thought. We hold our car keys between our knuckles to fend off attackers without ever asking ourselves why we don't demand more from the people who are really hurting us. We agree to stay home when little Susy gets sick even if we're in the middle of a major business deal. We don't meet many women business owners, so we never think this might be a viable path for us either. We just accept this is the way things are and assume that's how they will always be. Until you analyze your thoughts and beliefs, you might never know how many of them are not in tune with your intuition. You could continue to turn against yourself while leaving the door open for fear to influence your decision-making.

HOW FEAR IMPACTS OUR INTUITION

I see a lot of conflicting messages about fear, ranging from "Make fear your bitch" to "Feel afraid and do it anyway." There's even more confusion when it comes to defining the differences between fear, courage, triggers, and responding to them in a healthy way. My perspective is that fear is a good thing. It can keep us safe, and listening to our fear is the most authentic way we can honor our instincts and intuition. It only becomes negative when it causes us unnecessary suffering, or when we respond to imaginary fears rather than actual ones.

What if you reacted every time your body sent you a message that felt instinctual? You might think you're following your gut instinct, but you're really responding to a trigger or engaging one of your core defense mechanisms because you're afraid. It can be hard to tell the difference. A risky decision comes up, your brain starts feeding you all the reasons why it won't work, and you get out while the getting's good. Fear can also

blind you to your true intuition and prevent you from listening to your own wisdom. The more we give in to unexamined feelings of fear, the less we will trust ourselves to handle the next situation, where the stakes might be even higher.

Back in 2005, I was working in the technology space and had become friendly with some talented engineers. We began collaborating on new product ideas together, and our group patented several of these ideas, which was exciting for me. I'd been coming up with inventions and products since I was a little kid. I'd write letters to companies in crayon or marker, imploring them to use my ideas in their next product release. So one day, I shared one of my own ideas with the lead engineer, who had become a friend. He thought it had promise and tinkered with it a bit himself, and later shared it with his team. A few weeks later, he introduced me to an investor, and I shared my idea with him. He was interested and told us he would be willing to provide some seed funding to build the product. Some of the software engineers would even be willing to quit their jobs and work on this product with me. I was completely blown away. It was only an idea at that point, and these men, who had families to support, were going to ride or die with an inexperienced twentysomething.

I couldn't handle it. I became so consumed by fear that I wouldn't even let myself look at the possibilities. I was too sure that the product would fail, I would let them all down, and the investor would come after me to make himself whole. Instead of recognizing and expressing that fear, however, I just acted as though I wasn't interested. I pretended I was too busy, and I let it go. To this day, no one has brought a similar product to market; I know it was decades ahead of its time. I don't regret not bringing the idea to life, but I do feel sad that I didn't have enough confidence in myself to even try. I let what felt like the right instinct at the time (to say no) "protect" me from potential success. If I had simply analyzed the thoughts that came after that initial feeling, I would have discovered that I hadn't done any rational or critical thinking about this decision at all. I'd given in to the fear almost immediately.

It's situations like this when we need to examine the thoughts that come after that burst of fear. Then you can start to engage with your

rational brain and begin to tease out whether it truly is a risk not worth taking, or whether you simply need to spend a little more time preparing yourself to take the leap. It's just another example of why risk-taking should be a skill that you practice every single day. If not, you end up staying in your bubble, too fearful to try anything because of all the different things that could go wrong. Did you know that about 60 percent of American adults don't have a valid passport? There are multiple reasons for that, but one is the hyped-up negative media coverage of foreign countries, which is completely inaccurate when compared to the reality on the ground. Not all sources of information can be taken as gospel, and some of the media today is a questionable source. You can't give the same weight to all opinions, but it's difficult for some people to differentiate.

Whenever you do something that attempts to go against the grain, people who are still living in their own fear will have strong feelings about what you're doing. They will share their opinions, and often they'll try to talk you out of it. My mother certainly didn't want my sister and me to go to Panama. She didn't want me to go on any of my backpacking trips, for that matter, but I couldn't live her life. I had to live my life.

ASKING FOR HELP

According to the proverb, if you want to go fast, go alone; if you want to go far, go together. Great leaders recognize that they can't do it all on their own, so they hire people who complement their strengths and aren't afraid to say, "I don't know." However, for women that can be a bit of a double-edged sword because we've been taught to question our own thinking and seek so much external validation that we wind up going against our intuition. And when we no longer trust our intuition, we often seek outside help to decide what's best for us.

Natalie was one of my clients, and an incredibly talented consumer retail expert. She was driven and ambitious, so she ruffled some feathers along the way. The company she worked for was changing hands, and she had grown increasingly unhappy at her job. It took her a long time, but she finally decided to make a move and interviewed at three great brands. When she was struggling with which one to choose, she spoke

with three male leaders at her current company to get their opinions on which job was best for her. Although all three were successful and she highly valued their judgment, they weren't her, so their read on the situation only muddied the waters and prevented her from listening to her own intuition.

More confused than ever, she called me for help. When we met, I asked her to describe each of the three jobs, and I could tell immediately that she was leaning toward the smaller brand just by the way she talked. It was clear that was the best fit, but that was the job her three male colleagues had encouraged her not to pursue. It didn't have the same prestige as her current company, and it was a departure from what she was doing, so they made it sound as if it was beneath her. However, it would give her a chance to build something, and it was clear that's what excited her.

What happened was that she had taken on her colleagues' perspective as her own, but how she actually felt was different. I asked her a series of questions to help her separate what others were telling her from her intuition. Just by talking it out with me, she was able to realize that she didn't need to seek external validation because she already had all the data she needed to make the decision. She had just complicated the situation.

This is why it's so important to think about who you ask for help. Have they traveled down that road before? Are they female? If not, you might be asking people who haven't ever been where you want to go. You also need to recognize the difference between asking for help and asking people to tell you what to do. If your real question is "What should I do?" you're setting yourself up for disaster because you're giving up agency. However, sometimes we outsource these questions because we also want to be able to outsource the blame if things don't go according to plan. But if you really own your decisions and they resonate with your internal wisdom and truth, you don't have to fear being accountable to them; you can already trust they are in sync with what's best for you. And you're the only person who can know that.

Before asking for help, make sure that you actually need genuine, deep-level expertise that you lack. For example, if you're a female entrepreneur who is being approached by venture or private equity groups asking you

to sell your company, and you don't have any experience in that area, you should seek out an expert. Lay out the situation, pose your questions, and see if there are other issues you should be thinking about. Don't go to your friend who doesn't work in that world.

How you ask for help and how you frame your questions is important because other people are going to want to give you advice. You probably do too whether you realize it or not. We're all advice monsters, so when people come to us with questions, our reaction is to tell them what to do. It fuels our ego. This is what makes great coaches and therapists so valuable: they frame questions in a way that gets you to think differently about what you want to do, so you can reach those conclusions on your own. I always say to my therapist, "I'm tired of adulting. I just want you to tell me what to do here." We both laugh because we know she can't, but what she can do is give me a framework for thinking through a problem. At the end of the day, your decision-making will never be perfect, but you don't want to give up your agency and let others decide for you. That can lead you in a direction where you are turning against your intuition—and ultimately against yourself.

Sometimes it's difficult to tap into our intuition because not every decision is black or white. There are so many gray areas. Other times we're afraid to get in touch with what we truly desire because we have been telling ourselves and everyone else something for so long (I don't want to be in a relationship, I don't want to sell my company, I'm too afraid to be a founder, etc.) that we've created a whole identity and belief system around it.

The next time you must decide between two choices and are unsure how you really feel, try flipping a coin. This is a super simple way to check with your gut because when that coin is in the air, you will feel yourself rooting for it to land on one side over the other. That cuts through all your biases to tell you what you really want. If your coin lands on heads, which means staying at your job, and your gut reaction is disappointment, pay attention to that feeling. That is an important piece of data because it's coming from the true you, even if you can't articulate it or even admit it to yourself. It's a great way to cut through the brain's heuristics and get to the core of your feelings on the matter.

HOW TO GET IN TOUCH WITH YOUR INTUITION

One way to start building trust with yourself and your intuition is to recognize that every single decision and risk you take is both rational and emotional. People may say they want to take the emotion out of a decision, but that's impossible. The prefrontal cortex (PFC) of our brains, where our executive functioning resides, works with the amygdala (which has a major role in our emotional responses) to arrive at decisions.

When I was earning my mindfulness teacher certification at the Search Inside Yourself Leadership Institute, I learned a great deal about this process, and they turned me on to many of the studies I reference in this book. One such study involved a patient named "Elliot" who, after having a brain tumor removed, suffered from a broken connection between his PFC and his amygdala. When his life started to fall apart, Elliot went to see neuroscientist Dr. Antonio Damasio. He had his reason, logic, and intelligence intact, but could not draw on emotion to make decisions, which made him incapable of deciding on even the simplest things, like where to eat or when to schedule his next doctor's appointment. Damasio discovered that the emotional centers of the brain are what actually prioritize decisions for us. Without using emotions, the data sets would be completely overwhelming on even the simplest decisions, and we would struggle to make any decisions in a reasonable time frame. If I asked you where you wanted to go for lunch, for example, but you couldn't access your feelings about the places I suggested. You'd have a list of restaurants, but no way of narrowing down your choices, because you would have only a list of facts, and no feelings about those facts to help you prioritize and rank them.

The truth is that you will always have to make decisions with incomplete information, no matter how much research you do. This is where being able to tap into your emotions for guidance can be so helpful. The only way to do that successfully is to be fully honest with yourself about what you really want and how you really feel about something. Your feelings will always come first, which is why we need to get very good at identifying them.

There's a famous experiment from the 1990s called the Iowa Gambling Task that was designed to simulate the role emotions play in decision-making. Participants were told that they could win or lose money in a card game, based on the values shown on the cards. They were given four decks of cards, but what they didn't know was that two of the decks were "bad decks," which were preloaded by the researchers with more losing than winning cards. After drawing about forty or fifty cards, players could figure out how to stick with the "good decks" and could begin to control the game. But after only about ten cards, without being able to explain why, players started to show a stress response (through sweaty palms) when reaching for the bad decks. Emotionally, they knew something was wrong before they could consciously explain it.

It all comes down to self-awareness, but it's hard to wake up one day and suddenly become more self-aware. Making that change can be difficult, so here are some tools and techniques to help you become more aware of your internal states, preferences, and emotions.

1. SILENCE

Thinking back to the definition of intuition and its Latin root, "to consider," we need to consider both our emotions and our thoughts when it comes to making decisions for ourselves. The best way to do this is to start introducing more silence into our daily lives.

When I start to feel disconnected from my body and too much in my head, this is the very first thing I do. I turn off the podcasts and the music, and I just drive in silence, walk in silence, and get ready for my day in silence. If you're feeling particularly low energy, it can be hard to do this at first. Your body and brain will scream at you to pick up the phone, turn on the speaker, or watch a movie. It's difficult to settle into yourself and let your thoughts and feelings come, because they might not be particularly pleasant, but the process pays dividends.

If you can only do this for five minutes a day, then do it for five minutes. You don't even have to be meditating (although that would be helpful); you can simply stare at the wall or sit in a chair and just *be*. It might not happen right away, but after some time of building more and

more silence into your day, you will start to hear your inner voice again. You may not immediately know what your next move should be, but you will at least start to know how you are really feeling. That's the most important step. Once you know that, you will start to get some indication of what you want, what makes you feel good, and what makes you feel bad. You might even learn something about yourself.

When I was feeling particularly disconnected from myself one winter, I signed up for a three-day silent Zen Buddhist retreat. I knew nothing about Zen Buddhism, as this was prior to my mindfulness training, but I thought it would be a good way to get out of my daily grind with two young kids and figure out what was going on with me. I was in for quite an experience. Zen retreats are extremely ritualistic; there are precise ways to do everything, from how you sit to how you eat, and there is a cacophony of bells that all mean different things—standing, kneeling, walking. If I hadn't been stressed out before, I definitely was now.

Sometime during day two, they had us do a meditation where we had to stare into another person's eyes for twenty minutes. I was paired up with an older gentleman I did not know, and after that bell rang, my mind raced to find a way to stare at him without really staring at him. *Should I look at one eye or two eyes? He's not blinking. Is he sick? Why isn't he blinking? Does he think I'm coming on to him? Does he want to sleep with me?*

This went on for a good seven minutes until I finally settled down and focused on the meditation. I had to wait out all the internal shenanigans and let my mind freak out for a few minutes before I could just be. After three days of silence, I realized something I had never consciously thought of before: I wanted more community in my life. I realized I had been in my own little family bubble with my two small kids and my husband, and life was hard. I wasn't making time to connect with anyone else, and that made me feel lonely and isolated. If I had never taken that time to get quiet, I never would have known that. Now I had information from my true self that I could build upon.

Honor your intuition by continuing to feed it with more of the things that make you feel peaceful in mind, body, and spirit. This will take time. Transformations come with the accumulation of little steps every day, not one sweeping jump off a cliff.

2. RETRAINING YOUR BRAIN CHATTER

Most of us have a running commentary inside our heads all day long, and if we were to put a microphone on this inner voice, it would sound like it belonged to the most vicious, spiteful, and petty person we've ever met. This chatter takes your mind down a dark alley into a bad neighborhood. If you're meant to trust your intuition, how you speak to yourself is of paramount importance. Would you trust someone who you thought was a total fuckup who couldn't do anything right? Me neither, which is why you can't keep talking to yourself like this.

Your internal critic is the source of most of your unhappiness, anxiety, worry, and fear. Your brain is always doing one of two things: ruminating about the past or worrying about the future. The key to peace is to stay in the present, but for most of us, our ability to do this is fleeting. It's too easy to get distracted by the millions of bits of information coming at us every moment. We simply can't process it all.

Breath work, silence, and taking the time to be alone in nature help quiet my internal monologue, calm down my nervous system, and allow me to realize that in this moment, right now, everything is OK. When my internal chatter starts to become a runaway train, I sometimes tell myself: *We don't even know what happens when we die! Why worry about this now?* In the book *Chatter*, author Ethan Kross calls this temporal distancing. Ask yourself if you will still care about this a year or ten years from now, to put things back into perspective.

The key to getting in touch with your intuition lies in your ability to make the unconscious conscious. Through mindful self-awareness of your thoughts, emotions, and actions, you begin to develop a keener sense of how you move through the world and impact people you meet along your journey. When I coach people to become more aware of what they are doing and how those actions are truly impacting them, they can start to choose a new, better path that is more peaceful, in alignment with their values, and congruent with what they believe is their true purpose.

3. GRAPES

GRAPES is a tool from cognitive behavioral therapy, an acronym that stands for:

- **G Gentle with Self.** This can be releasing yourself from an expectation, stopping your inner critic from judging you, or simply making a choice that makes your life easier.
- **R Relaxation.** Consciously do something relaxing, even for only a few moments per day. That can include calling a friend, meditating, walking outside, or taking a bath.
- **A Accomplishment.** Try ticking something off your to-do list. Even completing a very small task can give you the positive feeling of getting something done or doing something well.
- **P Pleasure.** Simply engage in an activity purely for its own sake, and with no other purpose than your own enjoyment.
- **E Exercise.** Get moving. Whatever you are capable of doing, set aside time to move your body.
- **S Social.** Engage with another human being in some way, preferably in person, if it's safe. We all need connection.

If you can do these GRAPES every day, even just for a few minutes, you will build a consistent practice of self-care and self-love. You will also regain trust in yourself and realize that you can truly take care of yourself, just like someone who loves you would. That's the antithesis of turning against yourself.

Find the tools and techniques that best allow you to tap into your internal wisdom. Intuition is unique to you, which means it only connects with your actual truth. So many women never realize they're obscuring their intuition with limiting beliefs, outside opinions, and other things they picked up during their upbringing that are not really in touch with their true selves. Unless you can do the work to uncover that truth, it's going to be difficult to tap into your intuition, which will make this entire process an uphill battle.

Intuition will help you separate what society says you need to be happy from the core desires that are *actually* necessary for you to live a happy and fulfilled life.

CHAPTER 3: NEED
GETTING TO THE HEART
OF WHAT REALLY MATTERS

"We live in a time when science is validating what humans have known throughout the ages: that compassion is not a luxury; it is a necessity for our well-being, resilience, and survival."

JOAN HALIFAX

A FEW MONTHS AGO, I went on a walk with a close friend who was dreading an upcoming work-related social event because she had been unhappy with her team for a while. She was led by a man she didn't respect; she felt her teammates could not perform at the same level as she could, and, worse, she actively disliked them. According to her, the feeling was mutual. There had been a history of backstabbing, gaslighting, and general bad feelings in her workplace. For the previous year, she had enjoyed not having to see them thanks to the pandemic, but that was starting to change.

She was already planning her exit strategy, so I asked her why she was going to waste what little time and energy she did have at an event for this shitty job at a shitty company to mingle with people she thought were assholes. Aside from giving them more reason to talk about her if she didn't go, she said she felt obligated. She felt that pretending there was still some camaraderie among the group was what she "should" do, because not going would just elicit more gossip. It might even make her next twelve months with these people more bearable. But from where

I sat, the only benefit was to keep up a charade that nobody believed anyway. To do that, she was willing to make herself suffer twice: once by giving up her private recharge time to hang around with people who drained her energy, and again by continuing to work with a team that didn't allow her to thrive.

All of us are doing some version of this right now. I *should* go to that awards dinner. I *should* volunteer at the school. I *should* cozy up to this executive I think is a jerk, because he's powerful in our organization. We even "should" ourselves about who we are as a person. I *should* be able to build this PowerPoint slide. I *should* be able to forecast this budget. I *should* be more organized. I *should* get better in shape. Since most of us don't truly accept and love ourselves as we really are, we conjure up a mental image of who we *should* be and self-flagellate any time we don't live up to this idealized version of ourselves. Psychoanalyst Karen Horney called this the "tyranny of the shoulds," and it is a major cause of suffering for most women I know, including myself.

Growing up my sisters and I felt like we were put into different categories: either athletic, creative, or studious. Janine was the athletic one, Tracie was the creative one, and I was the studious one. Subconsciously or not, we acted according to the label on our boxes. When I graduated college, I felt like I had to rise to the highest ranks of corporate America, because that's what everyone expected of me. Even though my true love was documentary filmmaking, becoming the corporate powerhouse was the story I adopted for my life, even though it wasn't enjoyable. It wasn't until recently that I realized my unhappiness was because I wasn't using my strengths or fulfilling my needs. I am now growing into an athlete and finally gaining the confidence to put my own art out into the world. When you tell yourself a story for so long, it doesn't matter if it's not true. It became a part of your identity so long ago that it's extremely difficult to just stop believing it one day.

That story that we tell ourselves and present to the world is our ideal selves; it's a combination of what our parents taught us, what we admire in other people, and what's acceptable to society. It's not the same thing as our real self, which only you and a few trusted people ever get to see. When your two selves are badly out of alignment, it leads to discomfort

and suffering, which makes it difficult to live out your purpose and operate authentically. And society has set strict physical, mental, and behavioral standards for women that make this authenticity even harder to achieve.

A friend of mine who runs a start-up incubator and venture fund shared how this conundrum plays out in her world. We were discussing why women sometimes dismiss their own experiences, especially when it comes to risk-taking. She told me, "A founder can have an incredible background and an interesting business, but then she gets in front of investors, and it's like she develops a kind of business dysmorphia and stops representing herself and her business. It's like she stops being who she is in favor of who she believes investors want her to be. And they can smell that out right away." In reality, she is the product in those moments, but her real self has no room to emerge, so if I were forecasting whether investors would take a risk on her, I'd say no!

In his book *Think Again: The Power of Knowing What You Don't Know*, organizational psychologist Adam Grant writes about a concept called identity foreclosure. It's a psychological concept that basically means a person takes on or commits to an identity before they even can explain why. It's another part of the story we tell ourselves. One example is a kid who says he's a Republican simply because his parents are. As adults, we do this in our careers all the time. I once had a super smart Ivy League-educated intern come to me for help on how to tell her parents that she didn't want to be an accountant. She came from a very traditional Asian family that prized "safe" professions like accounting and law. She wanted to be a marketer but was living out someone else's dream until she got sick of it during her junior year. There is a constant battle between our ideal self (who we think we should be) and our real self (who we truly are), and until you become self-aware, you might not even know you're fighting that battle.

I used to joke that when they were handing out maternal instinct, I was in the bathroom. I wasn't sure I wanted kids and made my career my baby until I was in my late thirties. Once I had kids, I realized I did have those instincts, but I lacked the same level of enjoyment I saw in the mothers around me. I love my girls, but I was not prepared for the long

bouts of boredom, the endless repetition, the lack of solitude or time for thinking, and the absence of adult conversation. I felt deeply guilty that I was unhappy in those early months. I felt like a fish out of water and longed to use my brain for things other than tricking a colicky baby into napping. I deeply respect stay-at-home moms, but it took me far too long to admit that I didn't want to be one.

Some women were meant to be mothers, like my older sister. An excellent elementary school teacher, she took to mothering like a duck to water when she had her first daughter. She just seemed to always know what to do and trusted her instincts as a mother. In contrast, I felt sweaty and anxious, and constantly questioned (and Googled) every decision I made during those early days.

Rather than admiring my sister and other wonderful mothers from a distance and respecting my own brand of good mothering, I chose to beat myself up any time I felt I was not living up to what I thought I *should* be doing as a mother. It still sneaks up on me almost eight years later, and not over big moments either. When my younger sister sent me and my daughter Grace a beginner sewing kit to do together during quarantine, we weren't even an hour into the project before I got frustrated with myself, yelled at my daughter, and was ready to throw the whole thing away. When I told this story to a friend, we tried to unpack it to understand why I got so frazzled by a simple children's activity. We determined that the issue was twofold. First, I was approaching the task like a perfectionist, so when I didn't get it right away, I felt frustrated, and I was telling myself that a good mother *should* be able to complete this task and have fun doing it. Second, and I don't know why I needed reminding about this, but my friend pointed out that I don't give a shit about sewing, which is why I'm not good at or interested in doing it. When I argued that part of mothering involves doing things your child enjoys, she said my daughter also didn't give a shit about sewing. She just wanted to spend time together.

For my friend from the beginning of the chapter, it was a work event; for me, it was a stupid sewing project; and for you, it's probably something completely different. Whatever the task, we often ignore what we need to feel whole because we are too busy focusing on what we *should* be doing,

instead of what we are *actually* doing—or, better yet, what we need to be doing. We must transition our thinking from "I should" to "I need."

Once you've tuned into your intuition and can use that to guide your decision-making, you can dive a little deeper to find the truth about what you really need. Be patient because it might not be easy to find. Your truth is probably buried under a few layers of shopping bags from a recent splurge you can't really afford, behind an empty bottle of Chardonnay, or in that Insta feed of "the best vacation rentals of all time" you keep stalking.

I see a trend among some women in which we're either covering up our actual core needs and desires with a bunch of material things that we neither need nor want, or we're hiding behind the needs of our kids and our families while pretending that running around to fill their needs is what really fuels us.

Any time I ask a mother how she is doing, ten out of ten times she replies by talking about how her children are doing. I usually listen patiently and then ask her again, "Yes, but how are **you** doing?" She usually looks confused, and it takes her a minute to tap into herself because she hasn't thought about it in so long. All this surface-level need satisfying keeps us nice and distracted from doing the work to really experience freedom and happiness by fulfilling a true need.

WHAT IS A TRUE NEED?

A true need falls into one of two categories: survival or growth. Remember the old Maslow triangle hierarchy you learned about in Psych 101?

Maslow's traditional hierarchy taught that you must first meet your physiological needs (food, shelter, safety) before you could turn to your relational and psychological needs (love, belonging, esteem). Ultimately, you reach self-actualization, or purpose, at the top of the pyramid once all those other base needs have been met.

That's already harder for us women than it is for men, because it's a continual challenge to meet our physiological and safety needs. We don't enjoy the same earning potential in most jobs, we're laid off more frequently and promoted less, our businesses receive far fewer

investment dollars, we are expected to take care of dependents before ourselves, one in six have been the victims of attempted or completed rape, and one in three have experienced violence by an intimate partner.[11, 12] It's difficult to get past all of this so we can focus on needs farther up the pyramid.

Author and cognitive scientist Scott Barry Kaufman has reimagined the Maslow pyramid as a sailboat: he placed those lower-level needs in the bottom of the boat, representing security. If you have holes in your boat, you either sink, or you spend all your energy trying to plug the holes and stabilize the vessel. Without a solid hull, you can't enjoy the freedom of exploring growth, or sailing. He says, "Ultimately, in order to grow, we need to open up our sail and be vulnerable against the inevitable winds and waves of life. We can still move in our most deeply valued direction, even among the unknown of the sea ... Growth is a direction, not a destination."

The goal for the kinds of people like yourself reading this book is growth—doing purposeful work that is aligned with our needs and our values. Maslow and Kaufman give us two frameworks to define the dynamic progression of basic human needs, but within each level of their models, each of us has a set of individual needs that we deem necessary for our own survival and growth. For example, a need for connection in some people means that they need to participate in community activism or join groups and clubs that meet face to face. For others, connection is derived through writing, reading, or performing. What do you absolutely need to have in your life to feel like you are moving in the direction of growth at this moment in time? I like to help clients better define their needs if they're struggling by having them think about their life like pieces of a pie, I call the **6 Foundations:**

11 "Victims of Sexual Violence: Statistics," RAINN, accessed July 8, 2022, https://www.rainn.org/statistics/victims-sexual-violence.

12 Diana Boesch and Shilpa Phadke, "When Women Lose All the Jobs: Essential Actions for a Gender-Equitable Recovery," Center for American Progress, posted February 1, 2021, https://www.americanprogress.org/article/women-lose-jobs-essential-actions-gender-equitable-recovery/.

- Friends
- Family
- Fitness (mental and how you keep your body moving)
- Financial (what you do for money)
- Fire (romance)
- Fifth element (the thing you do for yourself that is independent of your relationships with others)

I ask them what would make them feel whole, safe, and happy in each of these areas? Do you feel like you can keep growing in each of these areas in the direction you'd like to go? Which areas are you feeling particularly good about and why? Being aware of your emotional state when you think about each of these areas and being honest in your own self-assessment is how you get closer to understanding your needs.

If you need some additional guidance, the best place to look is at your values because they are the north star by which you operate in the world. Values are the guiding behavior that you will employ to fulfill your needs. Whereas needs can be largely contextual and dynamic, values rarely change over time and circumstance. They influence your behavior when no one else is looking. Whenever you get lost or feel out of alignment in a relationship or a job, inevitably that means one of your values conflicts with something you are doing. In my experience, if your needs seem hard to define, the best next step is to get very clear on your values. Sometimes we need to reverse engineer into our needs from the place of our values because they give us important information. If you're having trouble coming up with a list of your values, the internet is full of amazing core values exercises. Start by making a long list, and then narrow it down to three to five core values.

Coming up with this list is one of the first exercises I do with my clients, and we revisit it any time they feel they may have veered off course or have a major decision on the horizon. This exercise requires trusting your intuition enough to say who you really are and not judging yourself for that fact, while also giving your insight into beliefs that you may not have vocalized previously. Beliefs are something you accept to be true, whether or not you have proof of its truth.

The best way to ensure that your needs are being met is by remaining true to your values. It's how you know you're walking your talk. Here's how needs and values and beliefs work together.

My top three values are intelligence, courage, and power. I was initially embarrassed about that last one, but that's because I placed a judgment on it, instead of accepting it as neither good nor bad. Somewhere in time, I developed a thought that people who had power or said they wanted power were self-serving narcissists (a "belief"). In this case, I defined power as the ability to influence people and decisions. By that definition, I absolutely want power. I am most comfortable when in a position of leadership. But how I acquire, utilize, and deploy my power is guided by my other values of intelligence, compassion, and accountability. If I come into power by being a jerk, I won't feel peaceful inside myself and thus won't grow in the right direction because I will know I am in direct opposition to my values. So, I know that I have a need to be in a leadership position that allows me to create a positive impact on people in a manner that makes me feel like I'm being authentic, not bending to the will of the organization. Intelligence to me is about acquiring and applying knowledge, while courage is about testing my limits. Check, check, and check.

Values and needs are inextricably linked. If you value something, that means you need it in your life to feel like a whole person. Think of your core values like an internal compass that will help guide you through life. When your values are not aligned with where you're spending your time and energy, you will feel like a fish out of water. If one of your core values is integrity, but you work for an organization that has shady accounting practices, then your need for integrity is not being met, and you undoubtedly feel uncomfortable in your current situation.

I experienced this after I hired a consultant to bring in a new scientifically validated tool called the Predictive Index (PI), which measures four key behavioral drivers behind your behavioral tendencies. He had me do an assessment. The result comes in the form of three graphs: one that represents your true and natural behavioral preferences, a second that demonstrates how you might adapt your natural tendencies to fit the current environment, and a third that represents how the rest of the world experiences you.

My results made me laugh out loud. Most of the outputs looked like a constellation, but my adaptation graph looked like a constellation that had been crumpled and thrown into an astronomical trash can. It was a Picasso painting. It suddenly became clear that I had been feeling like shit lately because I was expending so much energy trying not to be myself. I was forcing myself to handle duties that were not in line with my natural behaviors and drained my energy.

At my core, I had an entrepreneurial nature, no patience, and no interest in mundane details, yet I was in charge of leading a team of very green, inexperienced employees. They were lovely people, but they needed a lot of training, attention, and prescriptive direction. I had to expend a ton of energy and work very hard because that did not come naturally to me. I was stuck training people on the basics of business when my true talents, strengths, and desires were better spent on doing long-term strategic planning. None of my needs for growth were being met. The moment I realized that I hired a new manager who was better suited to those people-management tasks (and more interested in them) and changed my lines of reporting. The transformation I experienced in my happiness and growth felt like night and day. It allowed me to create a plan that got the company out of a multi-quarter growth slump.

I see a similarly destructive trend play out again and again in my high-achieving female clients: their positions are mismatched with their values and needs. I had several clients working at the same retail company who had a similar set of personal values (respect, impact, and collaboration), but their work environment was built on different values. The culture was monarchical, with one decision maker who dictated all the moves. The executive team dynamic was complicated and lacked trust, while each department operated as its own fiefdom. No wonder they were unhappy! They weren't getting any of what they valued in a work environment. But they couldn't see that because they were operating on autopilot, angrily working around the clock, and not taking care of themselves. No one was going to come rescue them. They had to learn how to think for themselves again about what was best for them.

It all goes back to the real self vs. the ideal self, but we can add more levels, given all the roles we play and how we view ourselves. If the real

self is who we are at heart, and the ideal self is who we want to be, the "adjusted self" is the person we present to the rest of the world. If you really want to twist your brain into a knot, you can throw in the "interpreted self," who is the person you think people believe you to be. There is a quote by sociologist Charles Horton Cooley that states, "I am not who you think I am; I am not who I think I am; I am who I think you think I am." It's the identity foreclosure process. We can easily foreclose into the interpreted self because we've armored up, or because we're worried about the "love and belonging" stage of the Maslow hierarchy. We're afraid that people won't accept us if we show them our real selves, so we start acting how we think people "expect" us to be instead of allowing ourselves the grace to change and truly be at peace. I've read that women reach peak happiness in their mid-sixties, and I believe one reason is because they've finally dropped all the pretenses of their other selves and finally settled into the person who was there all along.

But you don't have to wait until you're in your sixties. You can cut through all the noise and all the different versions of yourself by getting in touch with your values. Look at how you spend your time and energy and see if it lines up with your values. Work to root out and remove any mismatches because they only drain your energy and limit your capacity for risk-taking. Shifting out of autopilot can be incredibly powerful and will better allow you to fulfill your needs.

SEPARATING FACT FROM FICTION

Since need is an extension of intuition, the same things that can prevent us from getting in touch with our intuition can prevent us from clearly seeing our needs—such as our unquestioned beliefs.

When I was having breakfast with my sister Tracie one morning, she told me about a risky decision on the horizon. Tracie lives in a small village in England with her wife, Laura. My sister is very much an urban dweller and wanted the hustle and bustle of a larger city but was nervous that her wife, who was quite content to live in their current home, might not feel the same way, so she was torn. I wanted to learn what was preventing her

from taking action. I wanted to uncover her beliefs. I started by asking her one simple question: "Why do you want to move?"

"There's a community out there in the city—an active LGBTQIA presence."

"What about work? Both of you are happy at your jobs where you are. You just want to leave?"

I kept probing deeper, and we quickly uncovered that my sister had a belief that she couldn't have a community around her if she lived remotely, away from friends and family. But after asking only a few questions, we determined that wasn't entirely true. We were able to quickly uncover evidence to the contrary. She is the kind of person who has friends on every continent and actively keeps up with what is happening in all of their lives. She has more friends and people who love and care about her than anyone else I know. When faced with that fact, she realized that she does have community where she is. Her wanting to move had more to do with her being bored. "It's just grown dull here," she finally admitted. "I think it's run its course." Once we got to the real heart of the issue, we had a much better idea of how to solve it. We reframed her internal narrative, which had been causing her suffering, so she no longer told herself that she didn't have a community to support her unless she moved. She focused on routinely spending more time with her friends over the next year, and just recently moved with her wife and their closest two friends to a beautiful new city by the sea. Community and a new place to explore.

I recently coached a friend through a similar decision about whether to move to a new city. She claimed she wanted to move because she thought it might help her find a partner. Once we started exploring her beliefs around dating, we realized that it had more to do with changing her approach to dating, and less to do with her geographical location and "dating pool." In fact, the place she was considering moving to was a more suburban, family-oriented place, where her odds of finding a single man were even slimmer than her current location. She decided to stay put, start using a new dating app, and even expanded her dating search to places she traveled frequently for work. She hasn't found the right fit yet, but she did stop spending her free time stressing out about buying a house in an expensive and difficult market. Relieving herself of needing

to solve the wrong problem freed her up to continue to invest in growing her business, and she's having her most profitable year ever!

I have a close friend who is a therapist, and on a walk, I shared with her how difficult it can be sometimes to get a client to uncover their misguided beliefs, so they can realize their true needs. "We can be terrible at identifying our own needs," she told me. "The role that I play with my clients is to get them to look at their lives with scientific curiosity."

She explained that because humans are sentient beings, it can be too easy to fall prey to the opinions, judgments, and values of others. We adopt them as our own, even when they're not true for us. Our needs are dynamic, so observing ourselves with the curiosity of a researcher can help us step outside the swirl of our emotions and beliefs to think nonjudgmentally about our behaviors and problems. The scientific method is all about observing problems, developing hypotheses, and then experimenting to test your hypothesis. It's the difference between an observation and a judgment, which we often confuse.

My sister Tracie taught me an exercise I do with teams, where I ask them to pair up with each other, make three observations about the other person, and then report to the group. They usually get one observation correct: their partner has green eyes, curly hair, etc. But inevitably, the other "observations" become judgments: she is happy. He looks tired. An observation is neutral: we take in the facts that we observe and report them. A judgment is when we render an opinion about what we observe. A lot of what we think are observations are actually judgments.

Daniel Kahneman, in *Thinking, Fast and Slow*, writes about something called dual process theory. We have two systems of thinking: System 1 is thinking that happens more automatically (sometimes called lazy thinking), and System 2 is our more computational and reasoned thinking. When we think about ourselves through a more scientific lens, it forces us to override our System 1 thinking with System 2 thinking. That is not to say we should ignore our emotions and feelings. Feelings are still valid observations, but we can't always point to a specific example to explain a feeling and we shouldn't have to. I call these "internal observations," versus "external observations," which are based on factual evidence. This is also where intuition or gut instinct plays a role, because

even if we can't put a finger on why, our instinct can tell us to either move away from or toward something. If you are still not an expert at trusting or tuning into your intuition to determine a true need, there is a great exercise you can use to step through the process.

Years ago, a therapist friend of mine introduced me to thought records. This is a powerful tool that I continue to use with my clients because it can be transformational. Taken from cognitive behavioral therapy, a thought record can help you resolve a stalled thought process or more closely examine a negative thought or belief. It helps you step into the role of critical thinker by requiring you to supply evidence that both supports and contradicts your thought. Thought records are also excellent at uncovering any hidden biases.

I've filled out a sample thought record below that is loosely based on one from a prior client. There are many different templates for thought records; the one below has some of my own adaptations, which include identifying where in your body the emotions reside (furthering your own self-awareness) and asking yourself if there is an immediate action you can take to reinforce your new, more helpful thought. Sometimes the best action is to do nothing, while other times taking some kind of action can alleviate the monster-under-the-bed type of anxiety that comes with a thought. Either way, thought records can be done quickly and even in your head without pen or paper, so they are a great way to build self-compassion as well as your critical thinking skills.

- *Describe the thought or situation.*
 Everyone at this company is against me and trying to sabotage me.

- *How do you feel when you think that thought?*
 I feel sad, angry, and rage.

- *Where in your body do you feel it?*
 My gut bubbles and my fists clench.

- *What facts support your thinking?*
 Chad talks over me in almost every meeting.

- *What facts contradict your feeling?*
 Our COO tells me all the time how valuable my expertise is to the project.

- *What is a new, more helpful thought?*
 I am going to strengthen my relationships with my best advocates and let that be enough. You can't please everyone.

- *When you think this new thought, how does it feel?*
 Lightness and calm.

- *Where does that emotion live in my body?*
 I feel it in my chest.

- *Is there any action I can take to reinforce my new thought?*
 Formally ask for Jane to be my mentor.

As you can see, even in this thought record, there are questionable "facts." You will know this when you use the words "I feel" to describe your evidence, as opposed to actual hard facts. Again, having feelings about situations and thoughts is normal and expected, but unattended or runaway thoughts help no one. They usually cause immense suffering in the form of anxiety, negative loop thinking, and a feeling of pessimism about your situation. Sometimes using a thought record can dissolve the negative thought completely, while other times it provides clarity regarding your own needs and helps you see what steps you need to take next.

TRADE-OFFS

In 2008, I was stuck in a rut. I had been in a relationship with a man for two and a half years, but it was going nowhere fast. I was working in a Big Four consulting role that had me traveling Monday through Friday most weeks. I had been thinking about ending the relationship but was putting it off, and then something happened that made the decision much easier.

Late one night, I returned home from a long week of work and just wanted to go to sleep. The bed was made, which was a shock based on the usual lack of tidiness while I was away, but when I pulled down the covers, I saw a Jell-O pudding cup, with the spoon still in it, just sitting on top of the sheets. That was my moment of truth. I'm in my thirties, a great catch, and an intelligent woman. Why am I dating someone who is not worthy of my time and attention? It made me stop and think about what I was doing with my life—and, more important, about what staying in that relationship was costing me. What was I hanging on to? If I was being honest with myself, I was lonely. Work was challenging, and I was always on the road.

As a woman in your thirties, you start feeling pressure from society and the people in your life to have kids—like you're up against an imaginary clock. The idea of starting over with someone else is so daunting that you keep lying to yourself and forcing a relationship even when you know they're not your life partner. The fear of being alone keeps you there, but the wrong company brings you no solace.

What was I losing by staying? Well, I wasn't happy, and my confidence was eroding. I had put on weight, was not taking care of myself physically, and had started numbing out regularly. There was also the opportunity cost of staying, because while I was stuck in this relationship, I couldn't meet a partner who was better suited for me. When your career is chaotic, it's easy to get attached to the safety and security of your partner, even when you know deep down they aren't helping you grow. When I finally looked at what the relationship was costing me, I realized it wasn't worth it. I just needed to break the cycle. So, I ripped off the career Band-Aid at the same time I gave up my relationship security blanket.

There was an apartment a few blocks away that was right on the beach. I had been fantasizing about living there for a while, and it had recently been listed to rent. That same day, I walked over, put in an offer that was significantly more than my current rent, and got it! I'd left my job, had no reliable income, and hadn't even broken up with the guy I was living with yet, but I felt I could take the risk because of my track record. I knew I had a history of getting new jobs and starting over in different states and countries. I could make money, I was talented, and I was worth so

much more than I had been settling for. I had no idea what would happen romantically, but I couldn't stay in that relationship.

That night, I broke up with him, left all the furniture there, and moved into my new apartment. I had only an air mattress and a folding chair, but that didn't matter. I was ready to start over and living right on the water was incredibly healing. It wasn't long before I found a new job, at 40 percent higher pay, which led to a new career and, later, a new relationship. Leaving that day was the best decision I ever made. Had I not done that, I would have traded my potential and happiness for a false sense of safety and security. In the end, it wasn't worth it for me.

Not everyone can or should blow up the train tracks like I did. Instead, it's about consciously choosing *what is most important to you at this moment*. What was most important for me in that moment was to find my sense of self again. To design a new life commensurate with my values and goals. To be my own best advocate. To get myself to a healthier thinking space. I could be alone in my new apartment instead of trying to determine the future course of my life while feeling anxious and depressed because I was living with a partner I no longer loved.

Whenever I'm helping a client navigate a particularly risky decision, personal or professional, I always ask them to look at the trade-offs—specifically the cost of inaction. That's something that far too many people overlook.

When you consider your trade-offs, you will likely create a list of perceived benefits and losses. But our brains apply cognitive biases to our thinking that cause us to overestimate or underestimate both the risk and the perceived loss or benefit of taking the risk. Take public speaking: we think the (low) level of risk is equivalent to the level of our fear, and we disregard the potential benefit. Other times, we underestimate the (much higher) risk because the perceived reward is also higher (texting while driving, sex with the guy you met at the club that night). To appropriately weigh out your trade-offs, you must *separate the relevant risk factors* from those that are simply beliefs or fears. What is really holding you back? Is it really loss of income you're worried about, or is it fear of failure? Even if there are highly relevant risk factors, you can still devise ways to lower the risk potential.

Let's say you want to quit your job as a corporate lawyer and start your own bakery. You are single, you don't own a home, and you are worried about how you can afford to make the change. The first trade-offs are obvious: you will need to begin curtailing your spending and saving more money as you get closer to your departure date. Most people do the math up to the point where their income drops significantly, get scared, and stop. They believe they're thinking rationally, but it's really letting their fear get in the way. What would taking steps to reduce your risk look like? First, you could apprentice in a bakery with an experienced baker. You could stay in your current job, and work at a bakery on weekends while you learn the tricks of the trade. You could go to your local outpost of the Small Business Administration, where they could help you create a business plan and, in many cases, give you a low-interest loan to help finance your bakery. Local start-up incubators might have grant money to support you in your new endeavor. In other words, you can always take steps to mitigate the risks that are preventing you from getting what you need.

Trade-offs for most people translates to money, security, and title. Try adding a few more considerations to your list when you consider the trade-off of staying in the same situation, such as time, potential, happiness, and experience. I don't believe in work-life balance. I believe in trade-offs. You can have what you want, but you can't have it all at the same time. You have to acknowledge that you will be giving something up to get something else, which means that you won't be firing on all cylinders in every area of your life. While you're kicking ass in your career, speaking all over the country on your book tour or working long hours to raise capital for your bakery, you may miss a few soccer games or even anniversary dinners. You may have to RSVP "no" for the Vegas girls' trip. That will absolutely have an impact on your personal life but thinking in terms of trade-offs is not a bad thing. In fact, I think it can relieve some of the pressure to always be "on." I used to think I could have it all, and all at the same time. I joke with my husband that I have two speeds: on, and very on. Most of the women I work with can relate. But the results of operating at that level every day are insomnia, burnout, anxiety, and, in my case, crippling migraines and two ministrokes.

That's why it's imperative to prioritize your needs because you don't want to trade off the wrong thing. I've seen too many women do this, and it's just another way we can easily turn against ourselves. The first thing I ask every client to do before taking any big risks is to get their health in order. That means sleep, nutrition, daily exercise, and cutting back on partying. If they're struggling with some deeper mental health issues, I make sure they have a therapist or other access to mental health support. We talk about checking to see that you don't have any holes in your boat when it comes to your physical and mental health. That is a universal need.

You absolutely cannot trade off your physical and mental health for anything else. It must be your number-one priority.

The second universal need might surprise you: it's the need to be valued and heard. This goes beyond people talking over you in meetings and Larry parroting your idea ten minutes after you said it and getting credit for it. Everyone, male or female, needs to feel they're contributing to the world and be recognized and appreciated for that. I have yet to meet a single human being on this planet who does not want some form of recognition, and I've worked all over the world. I think this is especially true in the workplace.

What you can't do is ask other people to fill all your needs. Our needs are unique to us. Nobody but you can tell you what you truly need and desire, and we can't rely on our friends, spouses, or family members to provide us with everything we need. The better we are at identifying and servicing our own needs, the more capacity we have to enhance the relationships in our lives. I've experienced this personally, and I've helped friends and clients see it as well.

My client Kathleen is a longtime leader at a Fortune 100 company. As we talked about women and risk-taking a few years ago, I told her I didn't think women spent enough time examining the trade-offs of not taking risks. She wasn't totally following me, so I asked, "Have you ever thought of leaving the company?"

"Of course," she said. "I interviewed with a start-up for a completely different role last year."

"Why didn't you take it?"

She had to think about it a moment, but she told me, "Tenure. I've built up a reputation over the years." Then she added, "And good benefits."

Who cares if you're bored out of your mind? Ooh, the security! I'm joking, but that's a real consideration for many people who are the head of their household. The problem is that it's often fear cloaked as stock options. That's when I asked her, "What are the trade-offs of staying where you are?"

It wasn't obvious to her at first, but after some digging the answer became painfully clear. Potential. Growth. Happiness. Maslow called the higher level needs in his hierarchy "growth needs," or B needs (being needs). The lower level needs he referred to as D needs (deficiency needs). These needs are motivated by a lack of satisfaction, which makes us highly focused on achieving them. That can influence us to constantly chase the people and things that can fulfill those needs. We will actively avoid situations where we might lose resources for any of these needs: taking a lower salary to get out of a toxic workplace, risking employment at a start-up, or staying another ten years in boredom for a pension. Or, in a more personal example, staying with a terrible partner because our need to be loved is so strong that we would rather be treated poorly in a relationship than be alone and learn to love ourselves. Deciding to stay put or not take risks is not in itself problematic; it's only a problem if it's causing you to suffer.

That coaching session with Kathleen lasted about fifteen minutes. Two weeks later, she emailed me to let me know she was taking a new job. *That* is the power of realizing that you want and deserve better. But it's not always that simple, and not everyone can reach that conclusion so quickly.

There are a few ways to attend to your thinking so you can focus on your true growth needs and prepare to take the risks that will get you closer to them. Fear, cognitive biases, and old belief systems will begin to cloud your thinking as you try to identify and admit what you really need. And if you are like most women I know or have worked with, you might be a little scared to actually admit out loud what you really need. Our training to seek validation outside ourselves starts early. We start overthinking things or, if what we truly desire falls outside of what is

socially acceptable for women, become fearful of expressing what we need, so we might try to talk ourselves out of it.

Sometimes we can't admit what we really need because we failed the last time we tried to procure it. A great example of this is relationships. If something went wrong in our last several attempts at romance, it makes us less willing to throw our hat back in the ring. The same goes for asking for a promotion and being told "no." This is when I would ask you to redefine risk as opportunity, and rather than focusing on outcome bias (the relationship ended, therefore the initial decision to date this person was dumb), focus on what you learned, what went well, and what you could do differently to increase your chances for success next time. This creates a much healthier mental dialogue while building your confidence, as you can identify and give yourself credit for the things that worked in your last attempt. Instead of thinking about the risks it will take to fulfill your needs as "risky," think of them as being a great opportunity, albeit with some trade-offs you need to consider.

THE DIFFERENCE BETWEEN WANTS AND NEEDS

We must take full accountability for our needs, or we will forever remain restless while trying to find something that will make us feel better.

Many of the women I coach have similar habits and patterns; they're ones I recognize in myself as well, which makes it easy for me to identify them. They are all powerhouses, up to date on the latest trends and like to eat and travel well but are getting too few of their core needs met. Those material goods help pass the time and create quick little dopamine hits that feel good in the moment, but then they quickly return to their feelings of restlessness, sadness, and incompleteness. Whether I meet people in the high six figure careers or making $65,000 a year, almost all of them can clearly communicate their material aspirations but are far less capable of identifying or admitting what really feeds them.

We usually haven't analyzed the real emotional return we're getting from satisfying these surface-level wants. Often, this is the way we act when we're trying to avoid something. I know I'm ignoring my own needs

and regressing when my credit card spending shoots up. I keep all those thoughts at bay by overspending, overdrinking, overeating, and even overthinking. Instead, we should ask ourselves, "Do I really need this, or am I running away from something or covering up something I don't want to think about or feel?" The closer you look at your thoughts and actions, the more clearly you'll see that there is no connection between these surface-level wants and your long-term happiness.

Martin Seligman, the father of popular psychology, has deeply studied the pursuit of happiness and identified three strategies people use:

- **The Pleasant Life:** Seeking out pleasure. This is basically most of your twenties.
- **The Good Life:** Using your strengths, living in accordance with your values, and doing what you enjoy. If you're lucky, you start deepening your career journey right around your early thirties and begin to feel kind of like an adult.
- **The Meaningful Life:** Serving something greater than yourself. Many people I know miss this stage altogether, but hopefully we figure it out in our forties, fifties, or sixties. If we're lucky, we manage it much sooner.

Ironically, pleasure has no relationship to sustained happiness. Personal growth and serving others have the greatest impact on long-term happiness.

Instead of avoiding or distracting ourselves from uncomfortable issues, often what we need is a pattern interrupt, so we can start choosing a different path, and once we make new and better choices, we need to develop a way of keeping ourselves accountable to the promises we make ourselves.

CHALLENGE

Let's crystallize your needs by using Scott Kaufman's "needs" sailboat as a framework. Go through each of the three lower-level needs (self-esteem, connection, and safety) one by one and ask yourself:

"Do I have this need, or has it been fulfilled?"

If so, take note of the things in your life that make you feel fulfilled. These will be good to reference later should you find yourself coming unmoored in that area. Once these needs are fulfilled, you are in a good place to take risks because you will have no holes in your boat. However, if they are not fulfilled, ask yourself:

"What would make me feel this need has been satisfied at this moment in my life?"

Write down everything you can think of that would help fill this need. Maybe you need to spend more time with people you love. Perhaps you need to experiment with activities that might make you happy at this stage in your life. Maybe you need to change careers. If you have major holes in your boat, then your next action shouldn't be to explore risks, but rather to fix those holes so that you are ready for risk-taking.

Be warned: once you identify your needs and core desires, you will want to get started on fulfilling them, and the people in your life will have a lot to say about that. This is where you need to keep your resolve and your commitments to yourself, because it is not your job to carry the burden of other people's opinions and feelings about the choices you're making for yourself.

CHAPTER 4: DRIVE

WHY YOU DO WHAT YOU DO

"Success is almost totally dependent upon drive and persistence. The extra energy required to make another effort or try another approach is the secret to winning."

DENIS WAITLEY

MY FRIEND KATE WAS FURIOUS after learning she was passed over for a new job opening in her department last year. The role was one level above her title, but she didn't even know about it at first because her boss had created the position for someone he had previously worked with, which happens all the time in corporate America. She was seriously indignant that no one had asked if she might want the job. When she approached her boss, he seemed surprised that she would even be interested. "Of course, I would be interested!" she said, insulted that he would assume she didn't want to be promoted.

I agree her boss absolutely should have told his small team about the opening of a new position. That's just good leadership. But when I got Kate to move beyond her annoyance at what a crap leader he was, we started discussing the actual position. She read me the job description over the phone, and it was rife with spreadsheet management, report analytics, and other data management responsibilities that sounded horrifyingly dull. But Kate was fixated on the fact that she was qualified for the role. How dare he skip over her for someone who would likely be

less qualified? After she had finally vented all her feelings on the matter, I simply asked, "Do you really want to do that role?" Her current position was quite creative, and she got to do many things she loved: creating content, building online communities, and launching new products. This new job, promotion or not, sounded like she would want to stick a fork in her eye by the end of the first day. After thinking about it for a few seconds, she let out a surprised laugh. "No, I don't actually want to do this job," she admitted. "You're right. It sounds awful."

That conversation took maybe thirty minutes, tops, but in the week between when the position opened and we had a chance to connect, she had been living on pure adrenaline and rage. She had created a narrative in which she had been passed over for a promotion and had decided to fight for something she didn't even want.

The corporate ladder itself is old AF, and is a completely outdated concept for career progression, but it's still largely how corporations operate. This means that managing people is one of the only ways you can earn higher wages and better opportunities, whether you're good at it or not. So even if we love what we're doing, we all start suffering from FOMO at some point and set our sights on promotion as the true path to success. We get a sort of goal contagion: *Everyone else is duking it out for the leadership position, so I should want that too, even if the work itself sucks more the higher I climb.*

This is where things start to break down in corporate America, because there is no consideration for what really drives people and no attempt to match that with the appropriate roles. On an individual level, as long as we get the money and the title, we rarely prioritize our own motivators in our career moves, which is how we end up in roles that we despise—and that were never a good fit for us to begin with.

I find myself dealing with this all the time. I was once approached by a colleague who had a problem with a leader on his team who he thought was grumpy and unmotivated, and who had passed on that curmudgeonly attitude to the younger frontline sales staff he was supposed to be mentoring and coaching. My colleague had talked to him multiple times about his performance, but nothing changed. It was a smaller company and a collaborative culture, so we put our heads

together to find a solution. It was clear that this employee was not good at managing people or getting them excited about their sales goals. So, what was he good at?

I don't believe in trying to get people to build their weakest capabilities into strengths. It just never works. What I try to do instead is have each person work 90 percent to their strengths and less than 10 percent to their opportunity areas. This employee excelled at the technical side of the business—quality-checking the product, technical repairs, and IT break-fix issues. He loved to tinker and enjoyed chasing a problem down to its root cause. That's where he got his energy from, so we looked to see if we had a need for that skill set, and we did. We needed somebody with a specific level of expertise to babysit the product, and he had it, so we transitioned him out of having to manage employees and brought in someone whose ability to do that was one of their strengths. He was happier in his role, and the company got to bring in some great new talent. After several years in his new role, he was offered an amazing new career opportunity, and he left the company with a party, hugs and well wishes.

A move like that can immediately make a team stronger. As a leader, I find these conversations fairly easy to have, and the results are so freeing for both parties because nobody has to keep pretending. Employees don't have to pretend they want to do a job they dislike, and the organization doesn't have to suffer the results of an unmotivated leader, so everybody wins. At times I've had to say, "Look, we're both miserable. You're unhappy and the organization isn't getting what it needs, so let's not waste our time talking about performance management. Let's help you find a role in a different company." I've even paid recruiters to find people other jobs.

While I've had these conversations with employees and coached other leaders to do the same countless times, I've yet to see an employee approach their organization with the same concerns. Instead, I watch people remain in their jobs for years when it is patently obvious that they are unhappy. It feels too risky to tell someone we are not enjoying our jobs. But job satisfaction and performance go hand-in-hand, so the better we can identify what we like and what we don't, the quicker we can find relief.

DRIVERS VS. DRAINERS

When I coach leaders, my goal is to get them working toward their strengths and engaging in activities they enjoy while spending less time doing the things they hate. The first step is to identify what those things are, and I do that by having them write out two separate lists:

1. What are my energy drivers?
2. What are my energy drainers?

How do you tell the difference? Simple. Drainers are the things you avoid. You procrastinate and get a stomachache just thinking about doing them. For me, drainers are spending hours and hours reviewing spreadsheets, coaching very green staff, and all things accounting. Can I always avoid those at my level? No, but I also know they are not my strengths.

After discussing their drainers, I ask my clients, "What lights you up?" Drivers are the activities that you can do all day long. They give you energy, never make you feel bored, and make you lose track of time because they are well matched with your skills and strengths. It's that magical state of "flow" we all chase, the business equivalent of what athletes call "being in the zone." For me, those things are coaching high-performing leaders, problem-solving, team transformation work, and ideating new products and services.

As Kate experienced, drivers and drainers can be hard to identify on the surface because the phenomenon of goal contagion is real. We see other people doing a thing, and we tell ourselves that we need to pursue that goal too. The diet and wellness industry has made billions of dollars from this very thing. Add in the tyranny of shoulds and the way we manage to self-flagellate every time we don't make any progress toward this goal, and they become even harder to pin down.

We need to stop the madness. Decide which things you're willing to put in the work for and which things you're not. Stop brooding about the fact that you don't have your PhD if you aren't willing to or don't want to do the work to earn it. There's no shame in your game; just

stop pretending. Do you really want that PhD, or are you just afraid you'll have fewer job opportunities without one? Or is it really because everyone else in your family has one, so you think you need one too? If you decide you don't want to do the work, then hallelujah! Set yourself free and move on to something that does excite you. If you're like me, and you are addicted to suffering, then by all means, pursue that degree, but don't be surprised when you're miserable to be around five months from now because you have no free time and have forgotten what it's like to read a book that doesn't have equations in it. I can assure you with 100 percent accuracy that anytime you make a decision in your career that is not aligned with your drivers, regardless of the story you are telling yourself (more money, more prestige, more opportunities), you will regret it.

I've had to learn this lesson the hard way, repeatedly. After I got a little bored in a role as an individual contributor, I should have immediately said no when I was asked to come back into a department I had already left. I wrestled with that decision with my friends, family, and anyone who would listen. My husband finally asked me, "Wait, didn't you hate working in that department?"

"Yes, but this is a different role with a new title and more money, so it's just a stepping-stone," I said. "I'll leave if it goes down the wrong path."

Seven months later, I was coming home in tears every night because the same bullshit that sent me running the first time was happening tenfold this go-round. If any good came out of this, it's that I can now dissuade others from making the same mistake.

This happened recently when a former client was considering taking a role with a leader she used to work for during our first coaching engagement. We decided in ten seconds flat that it was a no-go when we reminded ourselves how painful it had been to work with her, and how unhappy my client had been in those days.

This concept of clinging to something that doesn't serve us is called grasping. Our brains like to ruminate on things in the past or worry about the future. Self-compassion gives us the power to release these painful thoughts that bind us and do the things that feel good to us. As women, sometimes we feel like we need a permission slip to do what we want.

I've even written a few permission slips to my clients to underline the point:

You want a permission slip? Here it is:
You're a grown-ass woman, and you can do whatever the hell you want!

Believe it or not, in my experience most people devote 75 percent of their time to the tasks that drain the shit out of them. They are shocked to learn that after we do a time study together, but it quickly becomes obvious why they have so little energy left to do the things they really enjoy. They are sapped from spending their time on draining activities.

Your job description might be different from your list of drivers, but you can always find a way to tweak your position to accommodate your strengths. Granted, this will require some candid conversations, first with yourself and then with your organization, but it is doable. If you're an entrepreneur, it's even more important to build a business around your strengths and hire a team that complements those strengths while offsetting your opportunity areas. Organizations I've worked with spend a great deal of time and money every year trying to measure "employee engagement." They drown themselves in satisfaction surveys and health checks, host town halls, and pay companies a ton of money to administer all this, when often all they have to do is go through this exercise and redistribute their work.

If you're in a position of leadership and have a team, or even if you're a solo entrepreneur working for yourself, look at how to delegate and offload as many of your drainers as possible to another employee or department. And there is always someplace they can go. This doesn't mean you're going to get off scot-free. You still might have to be responsible for some part of the duties you detest, but I often find people can offload more than they realize. You might have to get creative, but this is the first action step.

The second action step is figuring out how to replace those drainers with the drivers that get you energized. One woman's drainers are another woman's drivers. You might hate dealing with HR stuff, but perhaps there's a capable and excited leader waiting in the wings who loves it. If

you're in the early stages of your business and are still doing everything yourself, prioritize which roles you need to hire when you do get funding based on your drainers. The way you work will change when you plan it around your strengths.

If you can significantly improve that driver-to-drainer ratio, it's a complete game changer, and possibly a life changer, because when you're happy, plugged-in, and feeling engaged, your performance will improve. Even more important, you'll stop working from a place of fear and be able to focus more effectively on reaching your potential.

FOCUS ON WHAT YOU WANT, NOT WHAT YOU DON'T

Want to get in touch with your drive while remaining true to your needs? It may sound counterintuitive but learn to think in terms of what you *do* want, instead of focusing on all the things you *don't* want. Chalk this up as another lesson I had to learn the hard way.

I was always very clear on what I didn't want. After a long stint with a highly dysfunctional team, I filled an entire notebook page with all the things I wanted to avoid in my next professional engagement. I had been working with one leader in particular who was an absolute nightmare. She was hostile, abrupt, rude, impulsive, and narcissistic. She wasn't the one who had hired me, and I was not doing what I was hired to do. More important, I didn't have decision-making authority to remove leaders who didn't fit the culture I was supposed to help build. It was such an awful experience that when the difficult client called me years later to work with her at her new company, I told her I was too busy—the only time I have ever done that. Once that job ended, I knew I never wanted to work for another client like that—yet less than three months later, I found myself on another long project with an equally draining, equally dysfunctional team.

Looking back, the reason I fell in the hole in the sidewalk the second time around was that I focused more on what I didn't want than on what I did. I should have sat down and made a long list of what I *did* want in my next engagement. Had I done that, I would have known that this new job didn't come close to fitting those criteria. But there's something much

more important that happens beneath the surface when you do this. Hyper focusing on what is wrong or what you don't have in a situation only invites more of that thing into your life. It starts training your brain that you are focused on that one thing. Your brain cannot tell whether the thing is good or bad—just that it is important to you.

This is a function of your reticular activating system (RAS), and it's the reason why when you decide you are going to buy a red Jeep you see them on the road all of a sudden. Your RAS is simply highlighting what you are focused on at the time. It's like a Brita that filters out all the crap so the good stuff can come through, except that it doesn't make a judgment on what's good and what's bad. It just takes whatever you're thinking about and sends your conscious mind more of that thing. It's the ultimate self-fulfilling prophecy catalyst.

But if what you're thinking about is your goals and desires, the RAS will deliver what you need to achieve them, keeping your motivation high. Making this mindset shift is critical: even if you think the Law of Attraction is for weirdos, the effect of the RAS is a real neuroscientific finding that contributes directly to your overall life experience by impacting what you think about.

This is why most experts agree that keeping your goals visible and revisiting them daily (via journaling, meditation, speaking mantras, and even leaving notes all over the place) will help retrain your brain to focus on the things you are trying to bring into your life.[13, 14, 15]

One way I stay focused is to go on a diet from negativity and insulate myself from stuff that drains my energy. I stop watching the news. I stop watching my true crime shows (even though I love and miss them). I stop hanging out with people who are always in crisis and are hard to keep a conversation going with. You would not believe how many energy

13 Elliot T. Berkman, "The Neuroscience of Goals and Behavior Change." *Consulting Psychology Journal* 70, no. 1 (March 2018): 28-44. doi:10.1037/cpb0000094.

14 "Personal Goal Setting: Planning to Live Your Life Your Way," MindTools, accessed July 8, 2022, https://www.mindtools.com/page6.html.

15 Erin Eatough, "How to Set Goals and Achieve Them: 10 Strategies for Success," BetterUp, updated May 13, 2022, https://www.betterup.com/blog/how-to-set-goals-and-achieve-them.

drainers we allow to encroach on our daily lives in the form of social obligations. If that means I mostly hang out at my house, then so be it. It's worth it to keep my mindset clean and clear.

My therapist gave me a lens through which I try to make all decisions. It's a note I have on my computer that says, "Does this bring me value? Does this encourage growth?" If the answer is no, then I realize I'm likely doing it out of obligation or people pleasing, so I turn it down. Usually.

DRIVE AND RISK

Much of what we have discussed in each chapter are individual concepts with specific tools designed to help you in different areas, but it's all connected. I look at the **FIND HER** model not as a series of disconnected steps, but as more of a process or continuum that allows you to build momentum as you work through it.

Learning how to listen to your intuition will help you get more in touch with your values, which in turn allows you to identify your needs. Your needs become your inspiration, motivation, and drive. Then put it all together, so that when you're acting in accordance with your intuition, values, needs, and drive, the decisions you have to make and the actions you must take to achieve your goals will not seem as risky, which means you won't encounter the same internal resistance.

If you really desire something, you won't stress about all the ways you might fail. Instead, you'll do everything in your power to make it happen. It doesn't matter if that's buying a house, quitting your job to become a writer, getting your PhD, or having a child. If you decide that you absolutely want to do something, you will be so focused and become so knowledgeable about it that it will remove the risk factor from your decision. And if you go through the process outlined here, you'll develop self-awareness, which is a key step to better understanding what's going on in your brain, properly identifying fear, and calling it out for what it is so it doesn't hold you back.

That's the process by which you get your mind aligned, but that's only half the battle. Now you have to put your plan in motion by taking action. That starts with building a strong foundation.

CHAPTER 5: HABIT
SWAP SUFFERING
FOR FREEDOM

*"You do not rise to the level of your goals.
You fall to the level of your systems."*

JAMES CLEAR

JAMES CLEAR SAID THAT in his 2018 best-selling book *Atomic Habits*, and it blew me out of my seat when I first read it. It explained why I had been unable to lose some of the extra weight I'd been carrying for years. I was always motivated when I started, but that would dwindle and then I had nothing to carry me through the tough moments, so I kept losing and gaining back the same five pounds, when I wanted to lose twenty to thirty. What I didn't have was a system for losing weight, and I am a firm believer that structure creates safety.

I love this concept of structure because it removes the decision-making fatigue that often gets in the way of our drive. The reason it's hard for so many people to stick it out and actually experience change is that it doesn't happen all at once. It's a combination of a bunch of small actions that add up over time to make a difference.

Habit is basically the sensible older sister of need and drive. It's the net that appears when you've come down off the high of your great business idea and start to realize how much effort needs to go into living your dream. It's the bridge between wanting something and getting it done.

It's what separates the wheat from the chaff because if you aren't willing or able to create structure and a process around the things you want, chances are slim that you're going to get them.

If you haven't yet read James Clear's *Atomic Habits*, you need to pick up a copy immediately. Same with the habit books by Jen Sincero and Gretchen Rubin because there is nothing about habit I can tell you that these three authors haven't already said. What I will do instead is focus on habits as they relate to the **FIND HER** model.

THE REALITY OF CHANGE

When it comes to making changes in their lives, most people struggle because they approach the risks associated with it like they do dieting. They say, "I have to make this painful change for a little while, and then I can go back to how I was before and stop suffering."

That is not how true change works at all. I've seen clients get a win or two under their belts and then immediately retreat back to their old habits and mindset at the first sign of stress. More often than not, this isn't a problem that can be addressed by changing your habits. It traces back to the issues we just covered: values, need, motivation, drive, and, specifically, what many habit gurus refer to as having a strong enough "why" to achieve your goal.

Let's talk weight loss again because it's easy to demonstrate. If you need to lose weight, and your "why" is because you are currently unable to play with your kids and you want to be a more involved parent, that can be a very strong drive that will help you stick with a new system and structure. But if your "why" is because you don't want to be the heaviest person at your upcoming summer girls' trip, not only is that a weak driver, but it's also completely devoid of self-compassion. You will likely suffer while trying to meet that goal and will be shaming yourself along the way. Losing weight for your kids will still be challenging, of course, but that "why" is tied up with the new identity of a healthy parent that you're trying to pursue.

If you find yourself unwilling or unable to create structure around your efforts to change, that's probably an indication that you don't have

a strong enough why. In that case, you need to go back to the drawing board because the why will give you the energy to keep going when all else fails. Ask yourself, "Does the reason I want to do this match my values and bring me value? Is it helping me grow in the direction I want to go?" If you can affirmatively answer these questions, you're headed in the right direction. If your new habits are emerging because you're doing them for someone else, but you don't really buy into them yourself, you will not only fail at establishing the habit, but will likely also wind up resenting the hell out of the other person (as everyone who has tried to quit smoking for someone else can attest to).

If you're truly going to make a habit stick, it has to become part of the identity that matches who you are trying to be. If it continues to be an activity that lives outside your being, and your mindset is that it is short-term, you will only stick to it for so long. You either don't believe you're that new person, or you're forcing yourself into identity foreclosure. Don't believe me? I have the dusty guitar to prove it.

As much as I fancy myself a potential Bonnie Raitt, learning a new instrument as an adult requires a level of patience that, as you learned earlier, I just don't have. The same goes for the cooking classes and all the weird kitchen appliances I've purchased and never used—looking at you, Spiralizer—that were supposed to make me eat vegetables. The pole dancing class I signed up for and never attended also comes to mind. In each of these cases, I just didn't have a strong enough identity match. Instead of focusing on the big-picture lifestyle change I wanted to make so I could discover the new identity match (eating healthier or finding new ways to relax), I focused on the *things*: kitchen appliances, musical instruments, and workout equipment. I was perpetually stuck in the stage of *preparing* for a new habit, but not actually doing any of the things that would attach my identity to the habit and create the structure I needed to create change. Playing the guitar is badass, but that's not enough to make me practice for an hour every day. We have a finite amount of time, so we must prioritize the habits that will bring us closer to the person we want to be. I finally started to make true headway in my weight loss when I recognized that I wanted to identify myself as an athlete. I was inspired by women bodybuilders, but I was scared to take the leap—I was

intimidated by the process. Through research, I learned that bodybuilders are the best people to learn the concepts of structure, identity and slow and steady progress from. I took the first step and joined a program. I learned how to create structure around tracking and weighing food, how to train in the gym, and I adopted the mindset of an athlete, which directed my decisions about food and training in moments where my structure got temporarily taken off course by a change in schedule. In four months, I lost 20 pounds, and in 8 months, I could squat more than my bodyweight (and more than my 6'4" husband at the time!)

Let's use a business example. You hate your current work environment. Your boss is a dick, your coworkers are lackluster, and you're no longer growing in your role. You want to leave, but at some point, suffering became the new normal for you. It's easier to keep suffering than to face the pain of change (at least that's what you think). There is literally no one who left a horrible job for a wonderful new one who says they wished they had stayed in the crappy job longer. But the golden handcuffs of the bimonthly paycheck are strong. We tell ourselves that if we were to explore our options, we would lose our financial security and immediately plummet into the sea because the hole in our boat is so big. I don't mean to imply that as a woman, financial security should be treated lightly. There are many women who absolutely depend on that regular paycheck to live. But there comes a point that we become so afraid of income scarcity that we stay even when the cost is almost too big to bear. There is always another way to make money—you just might have to make a few temporary trade-offs while you explore those avenues.

When you're miserable but stay anyway, you're suffering without good reason. You're not suffering for a purpose. But once you start to identify your new why—using this job to your advantage, building the skills and experiences and money you need to start your own business—your why is clear and you have purpose, and therefore the suffering you must (sometimes) put up with is worth it. Many people either forget or don't realize that about this process. No matter what you're trying to do, it will be difficult and there will be times when you struggle. Of course, you don't want to suffer unnecessarily, but this process isn't about eliminating the struggle. It's about making sure that your difficulties serve a purpose

by helping you achieve a goal or get you where you're trying to go. But there are things you can do to make it more tolerable. Mindfulness, for example, helps separate you from your feelings, so you can recognize when you're in reaction mode and deploy self-compassion when you're overwhelmed by negative thoughts.

This is also where habits come in like a superhero. Once you've identified where you want to go, you must keep yourself and your brain in check. It will keep telling you to lounge on the couch and watch Netflix when what you need to do is work on your new website. If you wait for motivation to make sales calls to magically arrive, it won't happen. As my fitness coach always says, "You have to set yourself up for a game you can win."

One of the best tools in your arsenal to create space and structure for you to practice your habits is a calendar. Schedule your new habits into your work and home calendars—if you don't create clear spaces so you can establish your habits, you will continually give up your time to other people. When you have things scheduled, they are much more likely to happen. Scheduling your habits doesn't magically create motivation, but it removes some of the friction. Spontaneity was great in college, but if you're looking for transformation and goal achievement, you need to plan to succeed. In my experience with helping women set up new habits, it's not that we don't know how to plan—we are, in fact, naturally quite expert at planning. The real obstacle is prioritizing time for ourselves— hearkening back to the Maslow hierarchy. We feel guilty when we do this because it goes against what is expected from us by our employers, families, and communities.

When I've helped a client thoroughly examine their wants and needs and they still want to leave their current place of employment, the first action step we take is to look at their schedule. We eliminate meetings that are not essential and delegate wherever possible. We cut and cut until we create enough white space in their weeks for the tasks they need to accomplish to reach their goals. In this case the "drive" is exiting their job, so all their drivers must align with that goal.

Do you remember your number-one need, which you cannot trade off or sacrifice under any circumstances? It's your health. That's why we

include when they will exercise, meditate, or engage in other activities that prioritize their physical and mental health. We schedule this time consistently, every single week, because it will always be priority number one. We then move down the list of priorities (which are different for everyone) and schedule those throughout the week. We make sure that any executive support team members, such as admins, virtual assistants, or subordinates know this time is protected, and that under no circumstances can they (or you) schedule over it. You will need to tell your family and friends this as well.

The clients who succeed in changing their habits are the ones who can adhere to these time boundaries, even when everyone around them starts screaming, "Fire! Fire!" I work with a wonderful CFO who has the perfect phrase for these moments: "Your mistake is not my emergency." Here's another one: "Urgent always trumps important."

Habits are important, and they are consistent and routine, which is why they work. "Urgent" comes cloaked as a time bomb that will detonate in thirty seconds if you don't address it right this minute. As someone who has been working to make my health a new habit and priority, I could easily discern a true emergency from one that was self- (or other-) inflicted as soon as I decided my wellness habits were non-negotiable. Habits feel boring after a while, which is why ignoring them in favor of what sounds like a tantalizing "emergency" is easy if you aren't clear and committed to your why. For habits to work, you must protect the time you need to follow through on them zealously and without guilt. There will always be some emergency to attend to. Get out of the habit of handling every emergency yourself.

THE PROCESS

Habit is like the seal you put on a wood finish. It protects the surface underneath from all the bumps and dings it will take along the way. Habit increases your chances for success and can turn a possibility into a probability. But the more extreme the habit, the less chance it has for sticking. All the biggest habit gurus agree on this: the best way to really grow a habit is to start with a small change that you can execute

consistently, rather than trying to turn the ship 180 degrees on day one. If you're trying to create a wellness habit, try giving up soda for several weeks instead of going full keto or diving into intermittent fasting right out of the gate. If you want to start a business, perhaps begin by dedicating ten minutes per day to researching and building your business plan, and slowly increase that time over the next several months. Our society promotes habits much like we do risk: we love the stories of the extremists who suffer through quick transformations (but who likely fail later and end up back at square one), as opposed to the people who are quietly working with their heads down every day to get closer to their dreams.

When we think of habits, we tend to think of some kind of health-related habit, like fitness, nutrition, or sleep. I'd like to expand that view to include forming new habits in our mindset, thinking, and tolerance for risk-taking. Take that last one: if you start by practicing with smaller risks (speaking up in a meeting, commenting on someone's social feed), you can build your tolerance for bigger risks (leaving a bad relationship, starting your own business, asking investors for funding).

I believe this side of habits is underrepresented because we don't think about negative thought patterns as habits; we think about them as a "mindset." But thinking is habitual. The same loops that run through your mind today are likely the same ones that have been there for years. Eventually you just come to accept and live with those unpleasant thoughts instead of understanding that you can learn to rewire your brain.

Our capacity for brain rewiring, also referred to as neuroplasticity, is something we can direct ourselves by doing an activity that is new, interesting, and challenging. Learning to play an instrument, learning a language, and learning how to parent a child are all activities that can help this process of rewiring along.

Reflecting on how a good habit makes us feel is another way we can initiate neuroplasticity. This is important because our brain likes to be helpful and reinforce our habits, and our habit loops, regardless of whether they are particularly healthy for us in the long term. If left unchecked, your brain will just keep reinforcing your unattended habit of mentally shit talking yourself, especially if there's some kind of perceived

dopamine hit, or "reward," in it. It's just like that cocktail, that shopping spree, or that bag of Flamin' Hot Cheetos.

You can create the most helpful habits in the world, but if you can't connect and align what you're thinking to what you're feeling and doing, you will always wind up back in the same place. As women, our internal critics are on overdrive. Couple that with the rest of the world feeling much too comfortable judging us and our decisions, and reinforcing those negative loops becomes a common pitfall.

If we want to break out of our comfortable numbing and hiding habits, we must retrain our brains to start reflecting on the things we do that make us feel good and are good for us. When you think about why someone hasn't started a good habit or stopped a bad one, it comes down to this: she hasn't reflected on how it makes her feel. That is the best possible GPS you can use for how to get on the right track with mental habits. If your habitual thinking makes you feel bad about yourself, that is helpful data for where to start formulating some new habits.

The best habits I've developed are for assessing risk and taking decisive action. I've come to understand you have to act your way into thinking, not the other way around. Are you a generous person because you think you are generous, or because you act generously? The habit of never avoiding decisions has built up my risk tolerance, which means that I can confidently step into more and more complex decision-making. I have developed that risk-taking muscle that allows me to view decision-making as a natural act, rather than a special event typically associated with great psychological pain.

The habit of practicing self-compassion has been another game changer for me. I'm a big fan of Dr. Kristin Neff's model and research, which guides us to not overidentify with our moments of suffering and to remember the common humanity we have with other people who have suffered from some of these same things. Neff's model of self-compassion has three elements:[16]

1. Self-kindness vs. self-judgment
2. Common humanity vs. isolation
3. Mindfulness vs. overidentification

Instead of flagellating yourself in a moment of failure, try being kind to yourself. It means you adopt a gentler self-talk in those moments and speak to yourself as someone who loves you would. It means you remember you are not alone in your suffering or in your mistakes, even though it may feel like it at the time. It means you don't ignore your feelings about what is happening, but you don't exaggerate them either.

Overly identifying with our negative feelings can lead to reactions driven by fear. When acting from that place, we cannot be our best. Perhaps we get angry or blame others. For me, overidentifying with a negative event can lead to being hypercritical of myself and others.

Practicing self-compassion allows you not only to be more empathetic in your relationships with others but also more resilient and calmer in the face of failures or unexpected situations. It helps you be nimbler in your approach to problems and recover from challenging moments much faster. It's the single biggest gift we can offer ourselves when the chips are down—but it's also the issue many of us struggle with most. Self-compassion is how I can get back on track with my nutrition after a night of overindulgence. Instead of my old way of thinking, where I would just burn the whole goddamn thing down and start hitting all the kids' snacks, I simply go back to tracking my meals and holding myself accountable. And because I've been practicing this habit for so long now, it feels weird *not* to do it. It is fully part of my identity now.

I also had a habit of taking things too personally (middle child much?). This means that when people behaved negatively toward me, I assumed it was about me and something I'd done, instead of remembering that what people do and how they behave is about them. I've been practicing the habit of not taking on other people's behaviors and emotions as my own. In mindfulness, there is a word to describe this separation of one's own thoughts and feelings from another: *equanimity*. Now , instead of trying to "fix" the problem (or get pissed off when other people act like jerks to me), I just brush that shit off and go on about my day. Self-compassion

16 "Definition of Self-Compassion," Self-Compassion: Dr. Kristin Neff, accessed July 8, 2022, https://self-compassion.org/the-three-elements-of-self-compassion-2/.

helps me experience those feelings of rejection, humiliation, and dismissiveness but not to live inside them.

Unfortunately, habit can be boring, which is why good habit cultivation requires thoughtful and systematic consideration of your whole person. First, you must decide to take action. Then the key is to make practicing your habit as frictionless as possible until it is naturally woven into your lifestyle and no longer feels like something you're doing temporarily.

In my experience, bad habits are the result of an unattended mindset going on autopilot. Observe yourself like a scientist and think about why you put energy into something that is not bringing you value (or even causing you suffering).

Sometimes the consequences of the bad behavior become bad enough that you are forced to change. Maybe you suffer a major health issue, or you get fired from your job. Perhaps you're broken up with by a partner. A former mentor used to tell me this is the difference between knowing and doing the right thing. When your teenagers keep leaving their crap on the stairs, they know what they should do, they're just not doing it. Most times you simply need to stop and observe nonjudgmentally whether the habit is bringing you closer to or farther away from your potential. Is this activity good for you or bad for you?

That's the irony: we all know what we need to do to stop feeling like shit, but we just haven't found a way to set ourselves up for success. Think of anything in your life you want to change, or the countless conversations you've had with friends, family, and coworkers about the things they want to do but aren't doing, and it all comes down to systems and structure. Nothing is ever going to happen just because you feel like doing it.

CHALLENGE

Over the next three days, I want you to observe your thinking at various points throughout the day. Don't just leave it up to chance. Set an alarm on your phone every hour to remind yourself to check in on your state of mind. If you have a fitness watch that reminds you to get up every hour, you can stack your habits and

do this at the same time. When you check in on your thinking, it's common to find yourself sad, angry, stressed, or overwhelmed. That is often our default state unless we work to change it, and that's what this challenge is going to help you do. First, identify the thinking loop (positive or negative) you were stuck in right before you checked in. If it's negative, try flipping the switch so you can get in the habit of replacing that negative thinking with more helpful thinking. Note that I'm not saying positive, because toxic positivity is a thing, but helpful thinking. Even if there's still a twinge of worry, helpful thinking reframes your thought into something you can take action against or at least be more compassionate with yourself about. This exercise will be difficult at first because most people (myself included) are detached from how they feel. As they say, the eighteen inches between your head and your heart is sometimes the longest distance you'll ever have to travel. But if you do this consistently enough, you won't need the reminders because you will start to identify your own negative thought loops and flip the switch.

ACCOUNTABILITY VS. BLAME

Blaming and criticizing others is fun to do over margaritas with our friends, but it doesn't get us closer to a solution. We have already established that the system in which most of us work is not set up for women to reach our full potential. There are times when we are victims of a rigged set of rules, and there are also times when our wounds are self-inflicted. Just as you can fall into a habit of freebasing ice cream and gin every night, you can fall into a habit of blaming others, and that keeps you feeling like you have no power. I want to be careful with my words here, because I don't want to blame or fault women for struggling to find their way in an environment that doesn't protect or promote them. I know the system will not protect you, so I want to focus on a few things we can do and help you recognize the difference between being in an abusive situation and being on cruise control—where you are not happy but are no closer to making changes. That is the kind of situation I am addressing here.

The longer you stay in a situation that makes you unhappy, the more you will start to heap disappointment onto yourself. You may even start to believe that you don't deserve to be treated better. This makes it harder to leave a bad situation. We start to falsely identify with the person or people mistreating us rather than leaving a toxic environment, be it at work or at home. Sometimes, when we don't know how to productively work with the emotions that inevitably come with feeling unappreciated, undervalued, and disrespected, we can start to unwittingly damage other relationships in our lives.

In these times when you feel so depleted, your job is to learn positive self-management, so that you can experience your emotions while not becoming a product of those emotions. Like my clients who want to spend our time together indicting every single person around them who has wronged them in some way, you may be telling yourself that you can only control your own actions. But if you believe the problem is that everyone else is an asshole, you may not see that sometimes the asshole is you. If you walk around all day feeling triggered and anxious, you are likely creating a barrier around yourself that makes you highly unapproachable to the people who actually do respect you and want to work in partnership with you.

I know this because I have lived it. When I stay at toxic jobs or in bad relationships too long, I become an angry, anxious ball of resentment who is impatient and curt with the people around me. My internal chatter degrades into harsh self-criticism. I start isolating myself because I know I'm not good company, when that connection with friends and family would do me a world of good. I stop practicing my positive habits and revive old coping mechanisms (like turning against myself) that do not bring me closer to my goals. I know things are really bad when I stop listening to music. Before long, my entire outlook is negative, and it's hard to see any kind of silver lining, but it's not hopeless or irreversible.

Creating positive habits like **GRAPES** that focus on keeping what my therapist calls "good threshold hygiene" is critically important when you are trying to make big changes in your life. If you're not finding appropriate outlets to express yourself, you will begin taking out your frustration on anyone who happens to be standing there when you finally

have a DEFCON 1 meltdown because one benign comment tipped you over the edge. Being aware of your accountability to yourself when it comes to your own self-management is one way to take your power back and create a lifelong habit that will keep you feeling whole when it seems like everyone around you is trying to get on your last nerve.

HABIT IS NOT A SOLO SPORT

After years of running at a pace and level of intensity that was completely unhealthy and unsustainable, my body decided to revolt by having a stroke while I was chaperoning my five-year-old daughter's class retreat on a farm. One week later, I had a second stroke while waiting for my doctor to go over the results of my first stroke.

A battery of medical tests could not identify a cause, which led my doctors to focus on my lifestyle: my stress levels, my sleep habits, and if I was taking care of myself. I had to face the fact that what I was doing was literally going to kill me. I was not prioritizing my health but relying on my high pain threshold to just power through things. So, my body had to do something extreme to get my attention.

Having to completely overhaul my diet and exercise protocol was intense but has proved extremely beneficial in ways I could never have predicted. It built confidence and trust in my intuition again, knowing which decisions were good for me and which were not. I learned that I could set boundaries, even when it felt uncomfortable for others, but it wasn't always easy.

Because of my job, I must go away on a lot of retreats and business trips. But now I couldn't drink with everyone else, and I had to bring my own food sometimes. I had visions of being like my aunt with hypoglycemia, who brought bags of bizarre food with her everywhere she went. I didn't want to be that person—I just wanted to get drunk along with everyone else. I built up a lot of fear around what would happen when I had to sit down and have meals with the team, but none of it came to fruition. Once I embraced this new lifestyle and engrained these habits as part of my routine, I no longer identified with the person who had partied on work retreats and then felt like shit the next day. I learned

that without that, I was still myself. I still had a lot of laughs, and I still connected authentically with the team while they were whooping it up over martinis.

I always understood the power habits could have on my own life, but I never could have predicted or believed how committing 100 percent to this habit would actually influence and inspire the people around me in such a positive way. Several friends cut back their drinking after seeing how good I was feeling booze-free. My sister and her husband started their own exercise journey. The team that works closest to me are all prioritizing their health and fitness in new and more committed ways. Just as misery loves company, our positive habits can unlock empowerment, and connectivity in others. When people see you achieving your goals through consistent habits, they go one of two ways: they can immediately start flagellating and criticizing themselves for not already doing those same habits (goal contagion), or they can feel inspired to pursue their own big changes—either the same ones you've chosen, or ones unique to them.

I've been working very hard over the past several years on my mindset and overall lifestyle habits. These changes were subtle at first, because it had been a while since I threw myself a curveball, so I was leaning heavily on my existing skills and strengths, happy in my fixed mindset. It took months to establish some of these new habits consistently, and it was with the help of a community that I began to expand my self-view and lean into a beginner's growth mindset. As I became more in tune with my values and habits over time, I started to see and feel the results, which built up my confidence. I am convinced, for example, that if I hadn't been training my mindset and working my therapy tools, I would never have had the confidence to try snowboarding for the first time at the age of forty-six. Since I had become used to trying lots of new things the past few years, I felt confident and ready to try something a little riskier. And that is what empowerment feels like.

CHAPTER 6: EMPOWERMENT
TAKE BACK WHAT WAS ALWAYS YOURS

"People give up their power by thinking they don't have any."

ALICE WALKER

I KNOW IT FEELS LIKE WE KEEP ENTERING THE SAME MAZE, anxiously trying to find our way to the exit while the walls close in around us. We've been told by the media and the movies that there will be some climactic point in our career when we will know we have finally "arrived." We've got the title, the award, and the promotion, but even when we meet these objectives, that crowning moment of validation eludes us and leaves us wondering why we still don't feel worthy, happy, and complete.

Unfortunately, some of us never even meet those goals, let alone experience that elusive fulfillment. After defending our leadership titles like a heavyweight champ, waiting in the ring for the next challenger, we get worn down. We realize the definition of insanity is doing the same thing over and over while expecting different results, so we finally just quit—not just our jobs, but ourselves. I can't tell you how many women I've sat with who are, quite simply, defeated. They're as impressive, smart, and talented as they come, but they are tired of constantly defending themselves and justifying their decisions, so they give in—or, worse, become convinced they are not worth the work it will take to change things.

I think we women never feel like we've arrived because when we are chosen for executive leadership, we are expected to be grateful, humble, and even feign a bit of surprise that we have been selected for this prestigious role. The reason is simple:

Leadership is something given to men but gifted to women.

In my experience, when men are promoted into leadership, it's an expected inheritance from the successful men who were there before them. But for women, leadership is loaned out, with the expectation that we will need a lot of help. There is usually some preamble to let you know that you were given this opportunity *despite* your shortcomings. You haven't quite earned it, you're told, but the company is "taking a chance on you," and although they certainly won't be there with any kind of meaningful support, they're sure hoping you don't fuck it up.

How they decided to finally take a chance on you is usually through some kind of never-ending whack-a-mole game, where you must tick all the boxes on an imaginary checklist that keeps changing every time you think you're done. First you had to smash your sales targets. Then you had to clean up the mess the previous (and, let's face it, mediocre) leader left behind. Then you had to get your vendors in line and optimize your revenue streams. So, you did all that, but your performance measurement is rarely based on anything objective or quantifiable. Women are measured on style (that's feminine style, not leadership style), not competence. Many times, women are judged by how closely they resemble the man currently in charge.

Once women are gifted their positions, this is when the organization really starts to screw with them. Your performance must be flawless, or you will be held up to the light, examined from every angle, and scrutinized within an inch of your life. There are no gray areas. You are slaying it, or you are screwing up, and you can go from hero to zero practically overnight. If you make hard decisions, you're a bitch, not because the situation dictated the choice. If you don't choose to mother those around you, you're "not a team player." And if you match the tone and language of the emails sent to you by your male colleagues, you're

aggressive. If you are a woman of color, you will be judged even more harshly for doing or saying anything, ever, that runs contrary to their expectations of you as pleasant, easy to work with, and not one to rock the boat. And then they wonder why we leave.

So much of our limited energy gets redirected into anticipative stress about how people will react to some decision we've made, something we wrote in an email, or something we said in a meeting. It's hard to ever feel like we've arrived as leaders because we attach our feeling of arrival to other people. We don't feel legitimate unless some other person sees us in the light in which we want to see ourselves. We're subconsciously waiting for someone to tell us we are *already capable of great leadership,* without all the caveats. But when we surrender our power and our sense of worthiness to other people, many of whom are not worthy of us, we begin to question our abilities and feel like a shell of a person, instead of the whole person we want to be and, in many cases, already are. It took me feeling like I had lost everything and was at the end of my rope before I learned how to take that power back.

The retail business unit of the Fortune 500 company I was working for had been failing for years when I was tapped to help turn it around. In a matter of months, my team and I created a best-in-class sales unit, built a high-performing leadership team, and executed a consistent customer experience that finally helped turn that business into a profitable part of the enterprise. It was a particularly chaotic time for me since we did it all while I was pregnant with my first child. However, the rug was about to get pulled out from under me.

We had done such a good job of building back this profit center that our largest channel partner started to get nervous. The company had to decide whether to keep investing in its own direct-to-consumer channel or focus on sell-through with its largest customer. They chose the latter, which meant shutting down the business unit I had just spent two years building back from scratch. So, while on the brink of delivering my first child, I found myself jobless and terrified of the future. From a business perspective, it made sense: don't piss off your biggest customer! But I had left it all on the field to get us there, and I was angry, resentful, and hurt.

I knew it was a risk when I took the role. I had been in a comfortable and respected position doing innovative work that I enjoyed and joining a turnaround team did not make success a given. Looking back, trading some semblance of a life for a title and salary bump was absolutely not worth it. The company was failing, my peers were a dangerous combination of ignorant and arrogant, and my boss turned out to be a paper lion. Now I was entering the unknown waters of motherhood, unable to claim the identity of either mother or successful career woman. I was on the other side of a risk gone badly—but was that really the case?

Once I took some time to think about it, I realized I had been through the turmoil of 2008 already (my pudding cup-inspired breakup and job change), so I had some experience with the ephemeral nature of job security. I had also quit six-figure jobs in the past so I could fulfill my lifelong dreams of traveling the world. In each case, there was one common denominator: I was able to start over, I always managed to double my previous income, and I could move into work that was closer to my passion and purpose. I had already mourned this job, crying to my mom or a friend on the drive home from work at 9:30 p.m. I had been miserable for a long time, but the misery became normalized, and the suffering was addictive, so I stayed. On some level, I had convinced myself that it would all be worth it because someone would finally recognize my contributions and reward me accordingly. I was waiting for permission to feel a certain way about myself, and instead of feeling confident and successful, I had given this organization the power to make me feel shitty. And that pissed me off even more. I wasn't going to give them one more tear or allow them to make me sad for one more moment. I decided to empower myself to feel differently. I was embarrassed having to tell people that I was laid off, but I knew I had to break that cycle. It's not like I was the only person ever to get laid off. There were thousands of us in this layoff alone.

I had recently discovered Dr. Neff's model of self-compassion, which helped me remember that this job was not me, and never was. I was so much more than what I did for a paycheck. Did I even want to remain in a company that had lost its edge, working with people who didn't challenge me or the status quo in any kind of meaningful way?

I decided to go in a different direction. I took the risk of calling the president of the company and negotiating an exit package, which allowed me to not fret financially for the next year. I chose to focus not on what I didn't want or have, but on the things I wanted to bring into my life: peace, newness, gentleness with myself. I then wrote an email to everyone who loved me and was invested in me personally and professionally to tell them what had happened. I made sure to say that I was doing OK and looking forward to motherhood.

No one can outdo my family in the revenge business, and although you can find a certain level of comfort in having your relatives wish a pox on the people who do you wrong, I knew that it would just rev me up and prevent me from feeling any sense of calm. So I also made it clear that I would not be discussing the matter after that communication. I needed to put it all behind me.

There were still emotional ups and downs after that, but for the most part, I was able to maintain clarity. That allowed me to design a new career path that was a better match for me, putting me on track to become my own boss and pursue the part of my work I loved most: coaching and building an inclusive workplace culture and high-performing teams.

Habit involves women being accountable to themselves. When you are truly empowered, you stop looking for outside validation and answers.

WHAT IS EMPOWERMENT?

"The process of becoming stronger and more confident, especially in controlling one's life and claiming one's rights."

That's the definition of empowerment according to Oxford Languages. I had been empowering the company to dictate how I felt about myself and whether I had a career to call my own. When I decided to be laid off on my own terms, I took my power back. I decided not to overly identify with being laid off, and not to create a narrative around it that would prevent me from getting to my next chapter—and that put me in the driver's seat of my own life.

When you hear about "empowerment" these days, it often sounds like something women are waiting for someone to give them, when we all know we have to take that shit for ourselves. Even those of us who must remain in place temporarily for a variety of reasons can still create boundaries. We can still empower ourselves to build the bridge to what comes next. As I write this chapter, we are seeing a boom in black women leaving traditional employment to start their own businesses. Almost all of these stories are of women who were already building their empires on the side, not permitting the organizations they worked for to demand *everything* from them.[17]

The root of the word "empowerment" means "in power." That means having the agency to create economic, educational, and social opportunities that will allow you to make life choices with the same advantages as everyone else.

But the truth is that we are not equally empowered—economically, socially, and educationally. As women, we do not enjoy the same level of access as our male counterparts to the same resources, training, and cultural permission to fly as high. Several organizations measure gender empowerment annually, through indexes like the United Nations Development Programme's Gender Empowerment Measure. There is also the European Institute for Gender Equality's Gender Equality Index, the World Economic Forum's (WEF) Global Gender Gap Index, and many other indicators that are used to measure gender equality. Just a quick glance at the WEF's "Global Gender Gap Report 2021" will tell you that closing the gender gap has increased from 99 years to *more than 135 years since the pandemic*. This report looks at four main areas: political empowerment, health, economic opportunity, and educational attainment.[18]

[17] Patrice Worthy, "Black Women Say Goodbye to the Job and Hello to Their Own Businesses," *The Guardian*, posted February 12, 2022, https://www.theguardian.com/business/2022/feb/12/black-women-say-goodbye-to-the-job-and-hello-to-their-own-businesses.

[18] "Global Gender Gap Report 2021," World Economic Forum, Insight Report March 2021, https://www3.weforum.org/docs/WEF_GGGR_2021.pdf.

One major reason for the widening gap in 2021 is political representation. Women still hold only 26 percent of parliamentary positions and 22 percent of ministerial positions worldwide.[19] Unsurprisingly, another reason is income disparities and the few women in management positions, even though the educational disparities between men and women have closed significantly. When you read that report, it's clear that we have a choice to make: We can wait the rest of our lives for others to give us what we deserve, or we can go out and get it ourselves.

Most people don't think that turning over their own power to someone else is a habit, but I'm here to tell you that disempowering yourself absolutely is. You might be guilty of it yourself without even realizing it. Not sure? Here are some questions to ask yourself to see if you are indeed giving away your power to someone or something else: Are you in the habit of polling everyone around you before you make a decision? Do you find yourself stuck in analysis paralysis over even the simplest decisions? Do you routinely do what you think you should do versus what you actually want to do? Are you linking your identity and self-worth too closely to what you do for a living? If you were fired tomorrow, would that collapse your entire sense of self? Do you constantly guilt and shame (or question) yourself for the decisions you make? Do you feel resentful when you don't get what you want at work? Do you care a lot about what other people think of your decisions?

When I was talking to a friend and her family about this book during lunch, this point was not lost on my friend. She asked, "Have you ever once heard of 'dad guilt'? That's not even a thing. Even for a totally involved father like him," as she pointed to her husband, who was busy entertaining their four-year-old. "He doesn't give one thought to feeling badly about working. Not one."

In this case, both my friend and her husband were self-employed, successful professionals, but my friend admitted to slowing the growth of her practice because she was worried that it would take time away from her family. I went through the same feelings of guilt when my own

19 "Global Gender Gap Report."

business took off, and I traveled a lot while my kids were infants. And that, my friends, is one major reason why our gender parity numbers are for shit. The expectation is that we need to hold the family together and yield our career ambitions, because we typically don't earn as much as our male partners. For single mothers, you might have to exit the workforce entirely because there is no affordable quality childcare.

Remaining in a position where we have to give our agency and power away to other people is exactly what breeds resentment and can make us act out in ways that don't serve us. So many of my female clients get tripped up in corporate America because their careers are at the mercy of some male leader (or several) who finds it easier to work with people like himself, instead of people like her.

I also coach many male executives, and I thoroughly enjoy it. I don't believe we can get the system changed without their support and active participation. It's easy to see where things are going off track. I've coached male C-suite executives who have admitted to me in a moment of candor that they are "afraid of" their female leaders, or who simply struggle to communicate with them since their styles are so different. And God forbid someone cries or a woman gets really angry at work. They are not always willfully trying to treat their female employees differently, but in many cases, they are, and this impacts their ability to build and lead great teams.

The messages to men about female empowerment in the workplace have gotten grossly botched. I see some men being purposefully obtuse, and I see others who are genuinely confused about the messaging and disinformation on how to become better allies and activists. This runs the gamut from men avoiding their female employees so they can't be falsely accused of sexual harassment (a backlash from the "Me Too" movement, which typically leads to women not being mentored as often or as invested in as their male counterparts), to not understanding how to build alliances with the women on their teams ("If I tell Gary that he's talking over Tasha, will she be pissed that I'm trying to fight her battles for her?"), to complete obliviousness about how they divide their time and resources unequally among their team members ("David and I are both gamers, so we just kind of hang out after work. I'm not into the same stuff as Maria and Tianna").

I'm not saying that women need to take on the burden of educating their male leaders, but I am saying there is a huge gap when it comes to understanding what it truly means to build an inclusive culture based on equality. And women (as well as their organizations) are paying the price.

A PATH FORWARD

I have been asked to help companies address this workplace equity issue for many years now, and each time, I'm confronted with organizations that cannot get better because they will not admit they have a problem. They excitedly show me whatever "women's program" they have just launched, which typically is supported in name only by male and female executives, and is usually some form of:

1. A glossy report that tells the stories of a select few women who rose through the ranks traditionally, without any messy details.
2. Some after-work, after-hours affinity group that has absolutely no direct ties to professional advancement but does have monthly or quarterly speakers come in to tell women all the ways they need to keep working hard to get those coveted positions.

I have yet to walk into an organization and have its leaders tell me how they meaningfully address lack of promotion, pay diversity, and share of voice issues while closing gaps in their recruiting process that eliminate women from the candidate pool. I never hear about targets that are set to achieve better parity and what happens when the company doesn't reach them. Hint: nothing. Nothing happens.

Worse, I see plenty of Fortune 500 companies obfuscating the issue by tweaking gender and diversity data so that it looks better for the company. Sometimes they combine women and men of color hiring data with female promotions in the prior year—completely different data sets, which on their own look paltry, but when they're combined, the company can say they've increased by 30 percent!

Organizations don't want to look bad, but they also don't want to hold leaders responsible for creating inclusive cultures, mentoring and

promoting women, and hiring more equitably. They remain afraid to address bad behavior in some of their male top performers, lest they fall below revenue targets. They force-feed their employees borderline softcore porn versions of workplace harassment, which make women cringe and men and women alike resent that they are forced to watch this crap (and can't click ahead to the quiz).

They don't invest in coaching to help executives cultivate better self-awareness and learn how to have meaningful conversations with their teams and peers. When they do invest in coaching, it's either punitive or far too late for intervention. The damage has already been done, and the best course of action at that point is to simply cut out the cancer that is making the whole team sick.

The bad behavior of executives that I have witnessed from the front row would shock you. I have visited company cultures so broken that the female employees have no safe place to go when they experience abject sexism and unfair treatment. Organizations spend all their time trying to prevent risks like cyberattacks, profit losses, product launch failures, and losing customers. Rarely do they consider that the single biggest mitigating factor in preventing those risks is a psychologically safe work culture. Google (now Alphabet) itself identified what makes a high-performing team via Project Aristotle, but do they apply their own findings?[20] The 5 most important factors in order of importance are psychological safety, dependability, structure/clarity, meaning and impact.

The road to making work work for everyone is easy, but not simple. It does not happen overnight, but it absolutely will never happen if we are afraid to look the problem in the eye and admit that women do not have the same opportunity to rise as men.

If yours is one of those organizations that says it wants to do better, don't rely on the women in your organization to keep telling you how

Charles Duhigg, "What Google Learned from Its Quest to Build the Perfect Team," *The New York Times Magazine*, posted February 25, 2016, https://www.nytimes.com/2016/02/28/magazine/what-google-learned-from-its-quest-to-build-the-perfect-team.html.

to treat them better. Lead from the front, so they know you mean it. The solution is straightforward. Hire fairly. Ruthlessly hold yourself accountable for pay equity, promotions, and bonus equity. Put diverse leaders in place and ensure they have true decision-making power. Act like these issues are happening to you and respond accordingly. When you favor psychological safety over financials and root out the bad behavior, the performance will take care of itself.

In the most recent company I ran, I was able to partner with HR and every departmental leader to almost immediately change how many women leaders we had in the organization. And this was in a completely male-dominated industry that is not attractive to most people, let alone women. I felt confident that we had done a great job of creating a culture in which women could thrive, taking into consideration what needs they might have that were different from those of a male-dominated culture. We coupled that with our fair hiring practices and pushed ourselves to look at nontraditional backgrounds in our search for leaders. And since we installed more female and diverse leaders, our results have been clear in the hockey stick of record-breaking growth we've achieved year after year.

If you are already a leader or are building your own company, you have the ability to empower the people around you, so you must approach this issue with both intention and impact to hold yourself accountable for achieving the best outcome.

If you are not in a position of leadership, you still have power. You can study the companies you want to work for—read their stats on diversity and inclusion and ask them about their policies and how they determine fair market value for their open positions. At your current company, sit down with your direct supervisor and have a candid conversation about what you need from them to do your best work.

There is a simple exercise a colleague taught me a decade ago. Sit down with your manager and several Post-it pads, and then take turns asking each other what you need from the other person. You then each share specific things they can expect from you or three things you are committed to giving them. For example:

I need:

- Honest performance feedback monthly
- You to take a chance on me with some projects, even if you think I'm not 100 percent ready
- Your mentorship on how to be more visible to other leaders in this organization, so I can reach my career goal of X

I will:

- Execute excellent work product and deliverables on time
- Ask for clarity if I do not understand the direction you're giving me before I begin a task, project, or initiative
- Take any peer-related feedback directly to the source rather than talking behind that person's back

Whether you are mid-career or heading into the C-suite, the Post-it exercise allows you to advocate for yourself while holding yourself accountable for excellence. They're also a nice visual to put on your computer, so each of you can keep these commitments alive daily.

KEYS TO EMPOWERMENT

One reason I believe the **FIND HER** model is so effective is that all its components are connected. When you work to improve yourself in one area, it helps you improve in another. It helps you bring to the surface your own thinking about the world around you and about yourself. One example is working through your needs uncovers many of your limiting beliefs, because when we believe a story that does not belong to us or no longer represents the direction in which we are moving, that's just another way we give away our power.

One misguided belief I come up against regularly is that my role in life is to *endure*. I think of myself as being forged from fire, able to overcome any setback or challenge. This in turn has led to a belief that anything worth a damn doesn't come peacefully or easily; it instead requires hard work and pain. If something is effortless, I treat it as highly suspect and likely temporary. That's why it pisses me off whenever some idiot around

me seems to continually fail up and never has to sweat where his next meal is coming from. That belief activates my RAS, and that's why I still have to learn things the hard way.

True empowerment and growth for me is when I can choose the path of least resistance. You're looking at a woman whose father told her the night before her wedding, "Meg, let him win *sometimes*." But your beliefs are just one of the keys. Here are a few more that can help you learn how to lean into empowerment.

1. VULNERABILITY

True empowerment requires vulnerability. I don't mean making yourself vulnerable to people who are unsafe. I mean being willing to admit what you really need *to yourself*. Otherwise, you're simply obfuscating what you want and focusing instead on deploying your defense strategies when it doesn't happen or covering up the hurt you feel when a setback occurs. Or, even worse, living in resentment because you're stuck doing work you hate that isn't getting you any closer to your true purpose. The only thing this vicious cycle of fear, shame, and criticism brings you is self-doubt and more shame. If I can get my clients to tap into their hearts rather than their heads to tell me what they're missing, the tears almost always come. That's the moment they realize they have given up and no longer believe they can be brave enough to want something better. When you can express these core desires aloud (especially in front of a caring supporter), change happens. You can no longer ignore these parts of yourself that have been trying to get your attention all along. Vulnerability breeds intuition, which breeds trust, which provides the basis for taking the calculated risks that are best for you.

2. BOUNDARIES

Learning to set boundaries can help you get in touch with your intuition, and that will lead to empowerment. When I struggled to set boundaries, I gave up my time, energy, and resources to others, so their needs superseded my own. I thought of myself as a "servant leader," and for a long time that meant I had no boundaries when it came to my teams or my clients. And the more they needed me, the better I felt about

myself. But this often left me feeling depleted on weekends, unable to give my family or friends (or myself!) the best of me. I grew numb and regressed into my chief defense mechanisms: anger and resentment. I get destructive when I feel my time is not my own, and this anger starts to spill over in other areas of my life, such as criticizing myself, my husband, or my kids. Once I traced this back to my lack of boundaries, I started making new choices.

Setting boundaries requires courage and difficult conversations. Teacher and writer Prentis Hemphill describes boundaries as "the distance at which I can love you and me simultaneously." Loving yourself means setting healthy boundaries.

3. STOP STRIVING FOR PERFECTION

In his poem "La Bégueule" Voltaire said, *"Le mieux est l'ennemi du bien,"* which translates to "The best is the enemy of the good." Although both men and women can suffer from the weight of perfectionism, women experience a whole additional layer of societal expectations. How should we look, sound, and act? What jobs should we choose, and which ones shouldn't we choose? How should we feel about sex? Are we qualified to run for office or the PTA? Are we skilled enough to build our businesses, and how should we act if we want to get it funded? Optimization is about getting better than you were yesterday, but perfectionism is feeling like you never actually reach the destination. There's no actual arrival point for success or even empowerment when you strive to be perfect.

Empowerment builds on all the previous steps, especially cultivating the skill of intuition through the practice of self-awareness. So much of learning to make empowered decisions has to do with how you feel internally. You know you're getting close to that place of authentic empowerment when there is less dread, fear, discomfort, and insecurity associated with the process. Making empowered decisions comes with a feeling of peace. Even if it's a little bit scary, that comes more from excitement than from fear. If you feel like you are forcing the decision, drop the rope.

To reach true empowerment, you must understand your internal state pretty well, or you will continue to second-guess yourself. You

do that by matching your intuition with knowing (intellectually and cognitively) the benefit of what you're striving for. You've already done the work to determine what you need to become a whole person. You understand the difference between surface-level wants and true needs. True empowerment comes when you can bring your physical, mental, and emotional selves into alignment.

Now let's reevaluate the way you look at risk and realize that it is a skill you can learn like any other skill; it simply requires daily practice.

CHAPTER 7: RISK & REWARD

HOW TO INCREASE YOUR CHANCES OF SUCCESS

"I would rather regret the things I've done than regret the things I haven't done."

LUCILLE BALL

"WHEN IT COMES DOWN TO IT, WOMEN JUST DON'T HAVE THE RISK TOLERANCE."

That's what a prominent venture capitalist told me in 2019 when I asked him why, out of the $200 billion-plus worth of global venture capital funding that year, only 2.8 percent went to women founders, and an even smaller slice to BIPOC+ women.[21] I have no doubt he believed it, but I think that's total bullshit. It certainly doesn't match my own experience as a risk-taker. I traveled around the world solo in my twenties and thirties, started my own company, quit six-figure jobs with no safety net, worked in foreign countries, hang glided in the Swiss Alps, and slept in the jungle with wild howler monkeys, and yet a founder I work with closely tells me often that I'm not risk-tolerant. Why? Is it because he's

21 Gené Teare, "Global VC Funding to Female Founders Dropped Dramatically This Year," Crunchbase News, posted December 21, 2020, https://news.crunchbase.com/news/global-vc-funding-to-female-founders/.

willing to close on a multimillion-dollar deal in the moment, and I want to take a few days to perform some due diligence? Basically, yeah. That's how society defines risk: the possibility of failure (financial, physical, or emotional) x the impact of that failure.

Part of the reason women often don't think of ourselves as risk-takers has to do with the way we define the word. We think of risk as a zero-sum, high-stakes game associated with traditionally masculine behaviors like racing cars, gambling, and acts of heroism. Our culture values extremes and applauds peak performance. We admire those willing to put it all on the line, like the male founder of a unicorn company who was down to his last dollar before making it big or the basement trader who became an overnight success by exploiting loopholes in the system.

I have a female colleague who started three companies, serves on the board of several others, and is by all conventional measures highly successful, yet she feels she isn't a risk-taker because she decided to pull back her investment in a company that would not yield the returns she had initially calculated. In other words, she didn't bet it all on black. If anything, she should applaud herself for avoiding a bad investment, but instead, she tells this story with an air of sheepishness, like she didn't have the guts to go all the way.

Where has this thinking gotten us? Rogue entrepreneurs like Travis Kalanick (Uber) and Adam Neumann (WeWork), or many of the unicorns (companies valued at $1 billion or higher) that come out of Silicon Valley might be considered risk-takers, but often their companies are unable to reach their revenue and profit targets, and many times they struggle with cultural issues. During the early stages, investors want to get in and get out quickly, so the company often doesn't get a chance to build stable infrastructure. I'm not saying it's impossible to succeed with this approach, but it's problematic. It's easy to argue that both the housing crisis and the 2008 recession were born out of an addiction to dealmaking and playing with other people's money—a direct result of this same type of risk-taking.

I'm not an addiction therapist, but I've learned that risk-taking and addictive behaviors go hand-in-hand. Many of the male founders and executives I've met or coached shared a penchant for high-stakes

gambling, partying, and incessant dealmaking, whether or not the deal was compatible with their business strategy. They chased the dopamine hit and would come down very hard when they inevitably lost a high stakes bet. This is not the kind of risk-taking I'm advocating. Although these kinds of business decisions can certainly make you rich, many more people lose their asses and their assets through these bets. It's just not as sexy to talk about the losers.

You wouldn't know it from listening to the "conventional wisdom," but this isn't the only way to succeed. There is good evidence that when women run companies, their measured approach is better in terms of returns and results in less tumult within the company.[22] Even women venture capitalists can be quite different from traditional male VCs. They spend less, and VC firms with 10 percent more female investing partner hires have 1.5 percent higher returns and 9.7 percent more profitable exits.[23] They are also three times more likely to invest in women founders.[24]

Having a woman at the helm makes a difference—not just because they are bringing their unique perspective to the table, but also because it is so important for other women and girls to see women lead at the highest levels. "If she can see it, she can be it." People only take risks they think are possible, which means the more women we see in positions of leadership, the more possible it becomes for others to dream that big. And when women are in charge, they make waves.

Patagonia head Jenna Johnson was one of the first leaders to step out on a ledge and say their stores were going to be closed on Black Friday, so her employees could spend time with their families. For a retailer to close down on the single biggest day of sales was earth-shattering, but

22 Daniel J. Sandberg, "When Women Lead, Firms Win," S&P Global, posted October 16, 2019, https://www.spglobal.com/en/research-insights/featured/when-women-lead-firms-win.

23 "Venture Capital and Entrepreneurship," Harvard Kennedy School, accessed July 8, 2022, https://wappp.hks.harvard.edu/venture-capital-and-entrepreneurship.

24 Claire Diaz-Ortiz, "1 Change That Can Fix the VC Funding Crisis for Women Founders," TechCrunch, posted September 18, 2021, https://techcrunch.com/2021/09/18/1-change-that-can-fix-the-vc-funding-crisis-for-women-founders/

now a lot of the other big box corporations are starting to follow suit. Mary Barra, the CEO of General Motors, successfully led the company through one of its most difficult times. YouTube's success is due largely to the innovative work of CEO Susan Wojcicki. Bozoma Saint John took Netflix and the world by storm as the former CMO, widening the aperture on content to include far more inclusive and diverse projects and people. Indra Nooyi, former CEO for PepsiCo, is credited with leading major corporate restructure and diversification strategies for the company and makes regular appearances on the world's most powerful women lists.

I believe that if we can diversify who leads at the top, we will see a greater and more positive impact of businesses on the world around us, creating healthy workplaces where people can thrive.

Unfortunately, these stories are still the exception and not the rule today. Companies still don't think women have what it takes to make decisions at the top levels, and often when women do get placed in those roles, it's when the company is on the brink of disaster. In those cases, the woman leader becomes a good scapegoat for why the company could not recover—hence the term "glass cliff."[25]

WHAT ABOUT YOU?

Are you happy where you are? Are you working in a role that brings you closer to your potential and long-term fulfillment? If not, what have you done about that? The way I see it, if you are unhappy and unsatisfied in your job, you have three choices:

1. STAY AND FIGHT AGAINST THE ORGANIZATION TO CREATE CHANGE

Yes, it's noble, and it's what I did for a long time, but little actually changed. I'm not saying that organizations can't change; I'm saying that

25 Thekla Morgenroth, Teri A. Kirby, Michelle K. Ryan, and Antonia Sudkämper, "The Who, When, and Why of the Glass Cliff Phenomenon: A Meta-analysis of Appointments to Precarious Leadership Positions," *Psychological Bulletin*, 146, 9 (September 2020): 797-829, doi: 10.1037/bul0000234.

they're too slow, and we don't have time to sit around and wait. If your organization doesn't understand how to make the workplace welcoming and supportive for you to grow your career, it doesn't deserve you. Sure, we can keep trying to fight the good fight, but it will take us a hundred years to get the corporate monoliths to make the 180-degree turn to be fairer and more equitable, so this isn't the best way to go if you're unhappy with your current situation. I want you to go where you can thrive, but that may mean giving up on your current position and turning to option number two.

2. LEAVE YOUR CURRENT JOB AND FIND A NEW ONE WHERE YOU'RE VALUED

When talking about dating, some women say, "He may not be Mr. Right, but he's Mr. Right Now." That's pretty much how the corporate journey feels for women today, because so few companies are good at managing their talent. You're simply passing the time, but then, before you know it, seven years have gone by. Rising up through the ranks is almost impossible because you'll hear excuses like, "We're sorry, but you've already reached the maximum compensation for your role, so there's not much more we can do for you," or, "We appreciate you, but you need to understand that there is a freeze on all promotions right now." If you're a woman, you've definitely heard, "We're not sure you're quite ready just yet."

Not enough women leave when the relationship is clearly over. We confuse tenacity with insanity and fight to hang onto jobs that we don't actually want. Why, when all it does is chip away at our confidence, make us resent the world, and distract us from the power and potential we used to know we have? I don't want that for any hardworking woman trying to make her way in the business world.

If you can't get a serious commitment from your leadership team to help you create a career path that meets your economic expectations and professional growth goals, it is time to leave. If you can look in the mirror and tell yourself that you've done everything you can to succeed and add value to the work the organization is doing, and you still feel sidelined, unappreciated, or worse, *unaccepted*, then this place has nothing left to offer you. It's time to leave. And by that, I mean forge your own path

by starting your own business. I want you to pack up your dead plant and those dusty greeting cards your coworkers gave you for your birthday three years ago, grab your car keys, and go!

If this is the right option for you, remember that there are healthy ways to leave, and then there is burning the whole goddamned thing down. You don't want to do the latter. Just making the decision to move on is empowering. It puts you into a new frame of mind that will inoculate you from feeling the same level of rage and despair at the usual bullshit because you know you are destined for greater things. Shame on your company if they didn't realize this was coming after dragging it out for months or even years. Making a plan like this allows you to make your current role work *for* you, not against you.

Should you threaten to leave? Wave another job offer in your boss's face and use it as leverage to finally get that raise and that new title? No! No one leaves that conversation feeling good about it. You would still feel resentful that you had to threaten to leave for your contributions to be recognized and rewarded, and your trust in the organization would already be broken. At that point, you're simply working for the paycheck. The organization may feel sweet relief at first that they didn't lose such an MVP but will forever think you're just one recruiting call away from leaving, and it will likely stop investing in you, having failed to learn from its mistake the first time around.

Sometimes people really do need to leave for personal financial reasons, and in those cases, I have seen employee departures end on a great note with nothing but goodwill. If that is you, do your thing and expect the best. Most of us get to this point because we are tired of feeling victimized. But before you make the leap into a company that's just like the one you're leaving, take some time to reevaluate what you need in your next role to feel like a whole person.

These days, it's not wise to invest twenty years of yourself in one company. Women ask for promotions just as often as men do, but we are more likely to be turned down, so we often don't get promoted unless we make a change and go to another company or become our own boss.[26] If you're an engineer, you can probably leave your company and double your salary by going across the street. This can be a great option for some

women, but others soon find themselves in the same environment facing the same obstacles. But why is that?

In March 2021, according to "Women CEOs of the S&P 500" by women's advocacy group Catalyst, women held just 6.6 percent of the 500 CEO positions—that's only 33 out of 500 people, despite there being a record number of women in the workforce before the pandemic. None of those S&P 500 companies were founded by women, and only two companies on the list have female cofounders. That's not because 50 percent of the population isn't smart enough, daring enough, or capable enough. It's because women operate within a business system and a culture that does not make it easy or even accessible for us to climb that high. You cannot imagine the gaslighting, double standards, and different rules you must follow compared to your male colleagues. So, what do we do about it? That brings us to option number three.

3. QUIT AND START YOUR OWN BUSINESS

Most women won't do this because they consider it too risky, but I'm convinced it's the best option for many of us. The way we are forced to do business today is set up so that women can never reach their full potential. Ever ask yourself why there are no female equivalents of Elon Musk or Steve Jobs? Why are there more S&P CEOs named Michael or James than female CEOs, period?[27] Why do female business founders get less than 3 percent of available funding for their businesses?[28] It's because gender parity in our current workforce paradigm doesn't exist. We have to build it, and the only way to catch up is by betting on ourselves, taking a risk, and doing business the way we want to do business.

26 Benjamin Artz, Amanda H. Goodall, and Andrew J. Oswald, "Do Women Ask?," *Industrial Relations: A Journal of Economy and Society* 57, no. 4 (October 2018): 611-36, https://onlinelibrary.wiley.com/doi/abs/10.1111/irel.12214.

27 "Gender Equality in the U.S.: Assessing 500 Leading Companies on Workplace Equality Including Healthcare Benefits," Equileap, published December 2020, https://equileap.com/wp-content/uploads/2020/12/Equileap_US_Report_2020.pdf.

28 Jordan Rubio and Priyamvada Mathur, "Women in VC: An Exceptional Year for Female Founders Still Means a Sliver of VC Funding," PitchBook, posted January 10, 2022, https://pitchbook.com/news/articles/female-founders-dashboard-2021-vc-funding-wrap-up.

That may sound scary because it's probably been a while since you've been in touch with your true self. You're covered up by layers of self-doubt and years of armor to defend against micro and macro work aggressions, societal expectations, and the constant stream of negative chatter in your brain, all while you rush around busily attending to all the things that need doing. You probably haven't sat in silence with your own thoughts in so long that you don't remember what you like, what makes you happy, or what you want from the rest of your life.

This is a big step, and there are a lot of variables to consider before entertaining this idea, but if you've done the work up to this point and learned how taking risks a daily habit by developing that skill, you have already begun the process. But before you consider taking a major risk like this one, you need to make sure the rest of your life is in order first.

PRIME YOURSELF FOR RISK-TAKING

People joke about Mark Zuckerberg wearing the same outfit every day, so he has one less decision to make while he twirls his mustache and runs his billion-dollar enterprises. That always struck me as hollow. If our outfits were what kept women stuck, we'd have it made. I wish it was that simple, but I do agree with the general principle. If we're not living simply and reducing our decision-making overload, we wind up paying more attention to small issues and unimportant things than the really essential choices. Think of how much time we can spend looking for the perfect vacation house rental. We spend hours and hours obsessively searching online to make sure we choose the perfect house, poring over all 7,832 reviews, but for some reason we don't spend any time thinking about why we're willing to stay in a job or relationship that is making us deeply unhappy.

I started coaching Maya when she was leading the major revenue-generating arm of the marketing team for a well-known company. She was struggling to get the promotion that many felt she deserved. This was a whip-smart, Ivy League-educated professional with the complete package: intellect, vision, poise, confidence, and a decorated performance track record. She was so confident in her capabilities that she had asked

the company not to backfill a VP role when the former leader left. She was sure she could take on those duties as well as her current role and prove to them she should have the position, the title, and the salary package. So far, she was nailing it. However, some of her peers thought she was difficult to work with, so the company hired me to help her with a little style coaching, sometimes referred to as "executive presence," or "personal brand management."

It quickly became apparent that the company was taking its time promoting her, and she was getting itchy feet. She had been running circles around her colleagues, doing two jobs for the price of one, but instead of looking at her results and her ability to build a sustainable recurring revenue model and strategy, they focused on her "likability issues." She was being heavily recruited and could certainly leave, but there were some significant personal issues that were making it difficult for her to take that step.

Maya was recently married and had a young child, but that marriage was falling apart, and she was contemplating divorce. Although she was a great compartmentalizer, some of the difficulties at home were taking a toll on her emotionally, which sometimes bled over at work or amplified some of her challenges. When you feel like everyone is giving you shit from all angles, you can start to get a little short-tempered. Even though the company was indeed mismanaging her by dangling promotions that seemed to have movable goalposts, she was also getting in her own way. Before even considering the professional situation, it became clear she had to deal with her family issues first.

We found a therapist who helped Maya work through her personal struggles, and she and I began to create a strategy for building bridges at work that would get her closer to her promotion goals. Once her next steps with her marriage were resolved, as difficult as they were, she felt better and could think more clearly about what she needed professionally. She was primed for risk-taking. It was right around that time she finally got promoted, but it had taken so long and wasn't what she was originally promised, so it made her feel hollow. She had been chasing it for the better part of two years, and once she got it, it didn't make her happy. She knew she deserved more. Through our work together and her deep

internal exploration, it became clear what she was looking for, and the right opportunity presented itself when she landed the position of chief marketing officer for a top-tier wellness company. When her current company found out she was leaving, they tried to make her a Hail Mary offer to entice her to stay, but it was too little, too late. She had been asking for years, but it took her leaving for them to finally offer her what she deserved.

This whole-person concept of risk management is part of a bigger overall strategy that I learned when I went with the executive leadership team at a client company to a sharing session with a local Marine Corps squadron of fifty-three active-duty aviators. The lieutenant colonel in charge told us of a concept called "The Whole Marine." Essentially, if a Marine was not of sound mind, body, and spirit, he or she might be considered a flight risk and unable to fly that day. The pilots are required to disclose anything that might interfere with their decision-making upfront, including deeply personal matters. I adapted this concept into the work I do and refer to it as "The Whole Person." The same risk-mitigation principle holds true for us as it does for the Marines.

When coaching people, I look at the ecosystem of their lives and assess their risk-taking profile. If they have too many big stressors at the moment, I believe they are not primed for risk-taking and should address the overarching issues, or brush fires, before bringing new stress on themselves. Basically, you shouldn't make any big career moves when your personal life is a dumpster fire. Often, women assume they're operating from instinct when they want to burn all the ships and make a big drastic move, but it's often an attempt to distract themselves from something else that's going on in their lives that they need to resolve. To make sure that your desire to take risks is not an avoidance strategy, you first have to determine if you're primed for risk-taking. If the answer is yes, you are ready for the next mental shift you need to make in order to start taking more risks.

This is when risk forecasting can become a valuable tool. A weather forecast makes a prediction based on prior history and data. That can influence the decisions you make, from planning outdoor activities down to what you're going to wear. Risk forecasting does the same thing by

giving you an unemotional look at what looms on the horizon, so you can better determine which actions you need to take to increase your chances of success. It also serves as a good barometer for progress. Just as many financial forecasts compare the prior year to the current year, and just as you always try to beat the previous year's numbers, you want to do the same thing with the risks you take. That's how you know you're doing the necessary work to step out of your comfort zone and build up your risk tolerance. However, you can't accurately predict where you need to go until you honestly assess your history of taking risks.

REALIZE THAT YOU ARE ALREADY A RISK-TAKER

Most people stop at the point of imagining leaving a bad situation, because preparing a plan feels like a lot of work. It's also terrifying because many times we've been beaten down and our spirits have been broken. We are too tired or lack the confidence to make changes. However, I believe one major reason that some women never take the next step is because we don't think of ourselves as risk-takers, ignoring our track record of taking risks that we've spent a lifetime building up.

I have a good friend who worked in law enforcement for many years, leading high-profile cases, working in war zones and other dangerous environments where her life was at risk many times over. But when it came time to leave the public sector and start her second-act career in the private sector, she was willing to take the first job that came along, even though the pay was well beneath her earning potential and the job itself was not challenging. When she called me for advice, it became clear that this new world of salary negotiation was uncharted territory for her. In the public sector she had received steady 1 percent increases every year or so, but no major base salary increases, and she was afraid to take the risk of turning down this job in case another one didn't come along. I spent thirty minutes talking about what a badass she was, recounting her decorated career, and reminding her that if she could work in Iraq while bullets zipped over her head, she could wait a few weeks and let the risk play out in the job market. That's what she did, and about a month later,

she called to tell me she had taken a role in a Fortune 100 company with a base salary four times what she was making in law enforcement and stock options that would make you green with envy.

Another friend routinely worries about leaving her fairly stable corporate job to become a fiction writer. This person is one of the most intelligent people I've ever met, but over the past seven or eight years, she has developed a belief that she does not take risks; she does what is rational and secure. All we had to do is travel back in time to reexamine her track record. She left Eastern Europe as a teenager and, without ever having visited America, got a scholarship and attended grad school at a top-tier East Coast university. She came here with no family or friends, just the language she learned in school, and got hired by a top consulting company right after graduation. How many people would dare to do that? Remembering her past history helped to bolster her confidence in both her skills as a writer and in her ability to make big moves in life. She started writing again consistently, entered her writing into contests, and has developed a financial plan to leave her current role and work as a writer. She is about to take this leap as I write this chapter.

Remember who you are. If you've already identified your needs and know what you're willing to work for, you just need to apply the habit of betting on yourself to get where you want to go. When people push back on this option because the risk feels too great, I like to do a little exercise to remind them of what a badass risk-taker they already are. They just don't think of themselves like that. So, take a moment to explore a lifetime of actions you've likely already taken (or would be willing to take) that are actually really risky, even if you didn't think of them that way at the time:

- Pursue an education
- Choose a field of study
- Start a job
- Enter a relationship
- Buy a home
- Buy a car
- Have/adopt/foster a child

- Change a job/career
- Quit a job
- Move to a new home/city/state/country
- Travel
- End a relationship
- Change your physical appearance
- Play a sport
- Learn a new skill

You know how our brains can use fear to make a risk seem higher than it really is? Well, look at the risks on this checklist that you've already taken, or think about ones you've taken that are not even on the list, and ask yourself again if your decision to leave your job is really that risky. When you bought your house, did you put 100 percent of the money down, or did you take out a mortgage? When you decided to go to school in California from your small town in Iowa, did you have any friends or family on the West Coast to lean on, or did you have to make new friends and find your own way? When you had to end a long-term relationship, did you know how the other person would take it, and were you certain you would find another romantic partner someday? No! In each of these cases, you did not know the outcome. Add your own risks to the list, and you'll come to the same conclusion. You had to take a risk with whatever information was knowable at the time. How did you de-risk some of your former risks?

If you're considering leaving your current position to start your own business, there are all kinds of strategies to de-risk even that decision. You can increase your chances for success by creating a business plan and sharing it with various funding organizations, from local business incubators to the Small Business Administration to national grants focused on helping women entrepreneurs get their companies off the ground. You can do anything you want with proper planning, self-discipline, and good habits—but there are a few caveats. First, you really have to want it, and you must learn how to advocate for yourself both internally (with your mindset) and externally (with your actions). You also may need to delay gratification because these changes take time.

But knowing that you are working toward something, instead of running away from something, changes the mental game and increases your fortitude in sticking this process out until the payoff.

If you think this is impossible, I can promise you it's not. My friend Anna worked for a marquee brand, but always knew she wanted to build her own business. She had worked for years on nights and weekends building assessments and creating content for what she hoped one day would be her own consulting company but had never gotten any farther than that.

Her current job offered security, but she was unhappy. The situation only got worse when she had to report to a horrible new boss: a woman who did not support other women and a micromanager who made you feel like you were always doing something wrong. Anna couldn't take it anymore and decided it was time to leave, but she knew she needed a way to replace her income. She couldn't just build a website for her consulting business and expect the money to roll in. So instead of being reckless and impulsive, she put together a very smart plan, just as I recommend anyone do when they know they eventually want to leave their current company and do their own thing.

While still working for that marquee brand, she put herself out there to build up a network of developers, graphic designers, and technology experts she would need in her new career. She spoke at conferences, wrote white papers, and appeared on podcasts. She tested her content out on her network when she gave keynote speeches, while still remaining on topic for her current organization's needs. She provided coaching and assistance to people who would be good contacts later, even if it was unclear how they could help her at the moment.

With the groundwork laid, she gave herself a year before she could leave her current position and venture out on her own. That meant getting her finances in order. She banked bonus pay and base pay increases and didn't go on any trips because she knew she would need cash in the bank. She built a structure of deadlines for herself to complete copy for her website. She hired a design firm and got certified in tools that she could use down the road in her business. She began telling people she met at conferences that she also had her own business, which focused on a very

niche area of talent management. All this was taking much of the risk out of what initially seemed an incredibly risky decision.

When she finally left her job to launch her business, her network helped her stand up right out of the gate. Although her new venture wasn't cash-flow positive as quickly as she would've liked, she had planned for that, and she wisely kept reinvesting her revenue back into the business, knowing that it would pay off in year two. And it did! She now has the luxury of turning down business. People can certainly start over and succeed without such extensive planning, but they have to work a lot harder to do it, and we are trying to make your life easier, not increase its complexity.

Anna was successful because she did all the things successful business owners do, even before she started her business. She built a great network, she habitually called on her network to create new work, she reinvested her money into her business, and she didn't make any rash decisions. She worked slowly and steadily, turning the ship little by little, until she was fully out on her own.

A SHIFT IS UNDERWAY

As I sit down to write this, I'm listening to the media report on what they call "The Great Resignation." People are quitting their jobs in record numbers, despite being in the middle of a pandemic, a market bubble and rising inflation. The causes for this are varied—some people want more flexibility where they work, while others are leaving for the higher salaries they are being offered elsewhere in the midst of a new kind of war for talent. Some might just be sick of the bullshit at their current job, and even though they have nothing else lined up, they feel emboldened by their resilience in the face of all the pandemic has put them through. And women are leading the way! While many of us are being forced out due to dependent care and the quickly accelerating rise of child and eldercare costs, some of us still choose to leave our current jobs. Deep in our bones, we know they aren't worthy of us, and we know there is a better way.

Change like this doesn't occur all at once. It's a process that evolves over time, but we are starting to recognize that if we want to change the

playing field, we need to start playing in spaces as investors and business owners where we aren't typically welcome. We're seeing more and more stories of women-led investment in media companies, tech startups, and now even a major U.S. women's soccer team.[29]

And guess what? You don't have to execute everything to absolute perfection. To a gambler, every hand in a card game is its own universe. You might play ninety-seven out of a hundred hands like shit, but those three hands you play tactically better can cover others that don't go the right way. That is how you can take risks to get you closer to the life you want for yourself. Use the tactics you learned in this book to increase your chances for success.

Because I took risks right out of the gate, I got used to operating in new and unfamiliar situations. I developed the skill of agility. That skill made me feel comfortable taking roles where the stakes were very high, because I trusted my ability to learn quickly. And this is how, with absolutely no prior experience, I came to be in charge of a brick-and-mortar construction portfolio worth hundreds of millions of dollars.

It's the anticipatory stress of risk that makes people stay in their fear. Similar to getting a shot as a child, the fear was always ten times worse than the actual event. You need to learn, like my kids have, how to take a shot with the least amount of pain—by relaxing your body. You become more relaxed with risk-taking by trusting yourself (intuition), knowing what is really important (need), applying your limited energy resources toward the decisions that will bring you the most value (drive), reinforcing that with infrastructure that makes continuing to make good decisions easier (habit), and leaning into that momentum and drafting off your own successes (empowerment). The reward of your risk-taking is that brick by brick, you begin constructing the life that makes you feel fulfilled and purposeful.

29 Christina Settimi, "Serena Williams, Natalie Portman, USWNT Legends Bringing Women's Soccer to LA in NWSL Ownership Group," Forbes, posted July 21, 2020, https://www.forbes.com/sites/christinasettimi/2020/07/21/serena-williams-natalie-portman-and-uswnt-legends-part-of-female-ownership-group-bringing-womens-professional-soccer-to-los-angeles/?sh=6f7ad11d2767.

Whether you work toward changing your life from inside the system as a corporate leader or outside the system as a business owner or entrepreneur, you may have to find your way back to yourself again and again. My goal for you is that by using the **FIND HER** framework in the normal course of your life, you will learn to never leave yourself, and you will become so comfortable that risky decisions will feel lighter, nimbler, and maybe even enjoyable.

CHALLENGE

I want you to get off the starting blocks immediately, so we're going to do an exercise I do with my clients when they are at a crossroads. We draw a pie with six slices:

1. **Career:** Work that makes you feel fulfilled
2. **Financial:** Your money and assets
3. **Fire:** Your romantic connection
4. **Family and Friends:** The people you love and who love you
5. **Fifth Element:** The thing you do for yourself independent of all the other relationships. It could be a hobby, a personal challenge, your faith—something that is about you increasing your own personal growth. Said another way, what is the edge you're wanting to lean into?
6. **Fitness:** How you choose to stay physically and mentally fit

Your pie represents your current life. I'd like you to apply a percentage to each of these areas based on how much time you're spending in each area, knowing that it must add up to 100 percent.

Look it over and ask yourself: "Am I spending my time in the areas of my pie that bring me the most joy and that mean the most to me (my values)?" For most of us, the answer is no, and we need to make some adjustments.

Now make a new pie, built with the percentages that you want to have right now in your life. These will change as your life

circumstances change. What is the delta between your current pie and future pie? That is your next step. Understanding where you want to go and what is holding you back will put you on the path to building a life that is in tune with your values and your needs.

Sometimes we ignore our needs at our own peril, but don't accept less for yourself. You are worth the effort!

EPILOGUE

YOU CAN'T WORK THE MODEL ONCE AND CONSIDER YOURSELF DONE. You're always somewhere on the continuum of this framework, and you will have to find your way back to yourself again and again during your life's journey. Sometimes you're firing on all cylinders by tapping into your intuition, drive, and empowerment, while other times you will be stuck in fear. I am no exception. I make my living teaching this method to other people, but I get stuck like everyone else, and sometimes I have to learn the same lessons twice. I had to return to this model while writing this book when I found myself facing one of the most difficult personal challenges of my life.

On a beautiful fall day, a friend and I traveled about an hour away from home to a farm to join my daughter and her kindergarten class for their field trip. I was so happy to have taken the opportunity to volunteer, which is a constant challenge as a working mother. We arrived at an adorable little village that had been set up with Lilliputian tables and chairs for all the kids, who were excited to learn about plants and animals. After about an hour, we were shooed into a beautiful sunny garden. With my five-year-old sitting on my lap, I tilted my face to the sun and smiled, feeling so happy about being there with her in that moment.

That's why I was confused that my daughter, normally a little fairy sprite that skips everywhere she goes, started crying uncontrollably. I kept

asking her what was wrong, but she wouldn't answer me. Finally, I walked her to the little outhouse with the other kids for a bathroom break, but she was still crying and refusing to go in. I thought she was scared of the unusual toilet setup, so I asked one of the other mothers if the bathroom was dirty or usable. Except what came out of my mouth was complete gobbledygook. I was trying to ask, "Do they have toilet paper?" But what came out was something akin to, "Put the brush on the lawnmower."

I stopped, shook my head, and started again with the same question, but once again, what came out was a series of disconnected words. The mother and a nearby teacher just gave me wary looks as they shuttled the children to their next activity, and I dragged my still-crying daughter into the stall. I turned to ask her what was wrong, and again, garbled words came out. Then it clicked: I couldn't actually make myself say the right words, no matter what I tried. I frantically kept trying to talk to her while zipping up my pants, but the words coming out of my mouth did not match the words in my brain. I realized why she had been crying—I must have been acting weird before I even knew it. That's when I started to feel my tongue swell and the right side of my body tingle all the way down to my toes. By the time I came out of the bathroom, I knew I was having some kind of stroke. And I was in the middle of nowhere.

With a shaky hand, I dialed my husband. In between texting and speaking nonsense, I somehow conveyed "stroke" and "911," and hung up. I then limped my tearful daughter over to another mother, who took one look at my sagging face and undone pants and said very calmly, "I knew something was happening with you. I'm going to take your daughter and we are going to call an ambulance." I found out later that she was a pediatric nurse. She helped me secure my daughter with her teacher and called 911. I didn't want my daughter to see me taken away in an ambulance, so with a woman on either side of me, we walked up a steep hill to the main road, where I was taken to the closest hospital. The episode lasted about thirty minutes, and then my speech returned.

I had suffered what is called a transient ischemic attack (TIA), or ministroke. My brain scan was clear, and I was sent home. When I went to the neurologist's office the next week for a follow-up, I suffered a second episode right there in the waiting room. They immediately rushed

me downstairs to the ER. Once again, my brain scan was clear and I was sent home, but I still had no idea how or why this was happening to me, which gave me no comfort.

I spent the next month undergoing a battery of tests, but neither my neurologist nor the integrative medicine doctors could tell me anything more than that these episodes were brought on by a combination of my chronic migraines, stress, and lack of sleep. Basically, my lifestyle choices were causing my brain to short-circuit. As a die-hard workaholic, I eschewed the diagnoses for a few weeks but lived in a constant state of anxiety that these incidents would happen again, maybe while I was driving my kids around. I was scared, and my therapist finally got me to face reality and put myself and my health first.

What happened next was a top-to-bottom overhaul of my entire life: what I prioritized, what boundaries I needed to set, and what I needed to say while working on myself, my marriage, my role as a mother, and everything in between. Upon reflection and lots of difficult internal inquiry, I realized I had been hiding and numbing myself from the brush fires I had going on in my life by overworking, eating poorly, sucking down vodka martinis, and shopping erratically. All of this was to escape the grief of watching my parents struggle with their own health issues, my feelings of anger and resentment over how I was being treated at work, the disconnection that had appeared in my marriage, and the constant anxiety I had over whether I was making the right parenting decisions. I wasn't enjoying any of it, and I wasn't proud of myself. I was playing small when I knew I could be playing so much bigger.

What I did next was eat my own proverbial dog food. I went back to my own framework to find myself once again amongst the rubble, and I got myself back on a track that I felt good about. I am privileged enough to have some resources that helped me get there, like therapy and access to a fitness coach. But the most difficult progress was made in my own head. I needed to unpack the negative thought patterns and ill-serving beliefs that were no longer relevant to me. What was amazing about this process was that the minute I decided I would stop letting myself feel like shit, things started to get better. Making my health my first priority was very hard to do, and sometimes it still is. Women aren't used to feeling like

we deserve that kind of care and attention, especially when we have so many dependents relying on us, but it given me a newfound confidence and appreciation for myself that I've never had before.

I've since lost more than twenty pounds and started lifting my own bodyweight in the gym. I had very fraught and risky conversations where I put everything on the line in my career and demanded what I deserved but was prepared to leave. Luckily, I didn't have to, but I also put a very strong plan B into motion, just in case. I set boundaries and new expectations with people while planning for my future. I took the risk of being vulnerable and repaired relationships with friends—and, most important, my husband. I learned how to let myself feel good about my choices as a mother. To be clear, the work I am doing is not finished; I still have to make little choices every day that either support or undermine the new life I am building, and the results of those hard career conversations are unfolding even more layers as we speak. But as each new opportunity unfolds, I am clearer about what I need, what I want, and what I am willing to accept. I am confident in these negotiations, and unwavering.

Now it's your turn to start putting yourself first. Just saying that can cause some women to break out in hives. We think that if we make ourselves our own highest priority, the world will somehow stop spinning, but here I am, head still attached, and living on the other side of that risk.

Being a street fighter isn't about making every hill the one you will die on. It's about getting your hands dirty and knowing who you're really fighting against. It's not each other, and it's not the mirror. It's fighting for us and with each other. That requires a different mentality, but you now have the tools to make that change. I will see you in the ring!

ACKNOWLEDGMENTS

I would like to thank all the people who made *Risky Women* possible:

To my dad, Bill, who kept pushing me to write a book. To my mom, Eileen, who is my first and best role model for confidence and bravery. My sisters Janine and Tracie, who are my best friends and biggest supporters. My thought partner, Michaela, who spent countless hours debating the topics in this book, and without whom there would be no book. To Ryan Dempsey, who helped me edit and build this manuscript. To Christine, for jumping out on the ledge first, and teaching me from experience. To my SD crew, Caroline, Rebecca and Sharon, for our shared history and lifelong friendship. To JM, for guiding me in my own learning journey. To all my clients, from whom I learn as much as I might teach. I would also like to thank the authors of the many books that became my teachers over the years, and the Search Inside Yourself Leadership Institute for introducing me to important mindfulness research and for deepening my mindfulness practice.

Most importantly, I'm grateful to Mike, my husband, for taking on more so that I had the time and space to write, and for being in my corner every single time, no matter what. And to Grace and Lou, my babies, for being the best possible moments of levity and my reason for fighting for a better world for women. You are the most beautiful human beings I know, inside and out.

CPSIA information can be obtained
at www.ICGtesting.com
Printed in the USA
BVHW051325281122
652930BV00004B/46